The *Surrealists*

ART IN DETAIL

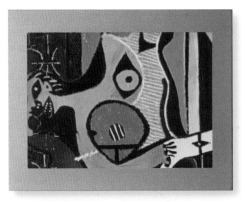

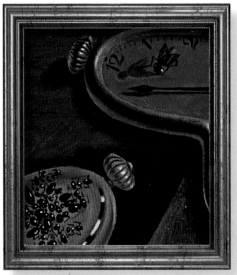

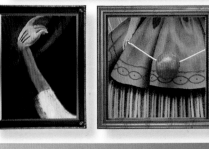

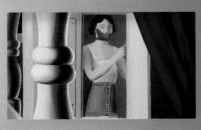

The

ART ⓘ DETAIL

Laura Thomson

METRO BOOKS
NEW YORK

This book was conceived, designed,
and produced by

Ivy Press
The Old Candlemakers
West Street, Lewes,
East Sussex BN7 2NZ, U.K.

Creative Director Peter Bridgewater
Publisher Jason Hook
Editorial Director Caroline Earle
Art Director Clare Harris
Senior Project Editor Dominique Page
Designer Helen McTeer
Concept Design Alan Osbahr
Picture Research Katie Greenwood

Metro Books
122 Fifth Avenue
New York, NY 10011

ISBN-13: 978-1-4351-0377-1
ISBN-10: 1-4351-0377-7

Printed and bound in China

10 9 8 7 6 5 4 3 2 1

Picture Credits
The publisher would like to thank the following for their permission to reproduce
the images in this book. Every effort has been made to contact copyright holders and
acknowledge the image, however we apologize if there are any unintentional omissions.
AKG Images: 32–43 (© ADAGP, Paris and DACS, London 2008), 74–79 (© ADAGP,
Paris and DACS, London 2008), 80–85 (© DACS 2008), 86–91 (© ADAGP, Paris and
DACS, London 2008), 104–109 (© Salvador Dali, Gala-Salvador Dali Foundation, DACS,
London 2008); Joseph Martin: 98–103 (© Courtesy of Michael Rosenfeld Gallery, LLC,
New York, NY). **Bridgeman Art Library**: 26–31 (© ADAGP, Paris and DACS, London
2008); Held Collection: 116–121 (© DACS 2008), 122–127; Lauros/Giraudon: 20–25
(© ADAGP, Paris and DACS, London 2008); Philadelphia Museum of Art, Pennsylvania,
PA, USA: 110–115 (© ADAGP, Paris and DACS, London 2008); Private Collection: 92–
97 (© Man Ray Trust/ADAGP, Paris and DACS, London 2008). **Corbis**/Francis G. Mayer:
32–37 (© Succession Picasso/DACS 2008). **The Robert Lehrman Art Trust**: Courtesy of
Robert and Aimee Lehrman, Washington, D.C.: 68–73 (© The Joseph and Robert Cornell
Memorial Foundation/DACS, London/VAGA, New York 2008). **Scala**, Florence: 50–55
(© Man Ray Trust/ADAGP, Paris and DACS, London 2008); The Metropolitan Museum
of Art/Art Resource: 44–49 (© Succession Miro/ADAGP, Paris and DACS, London 2008);
The Museum of Modern Art, New York: 8–13 (© DACS 2008), 56–61 (© Salvador Dali,
Gala-Salvador Dali Foundation, DACS, London 2008), 62–67 (© ADAGP, Paris and
DACS, London 2008). © ADAGP, Paris and DACS, London 2008: 14–19.

Cover image: © ADAGP, Paris and DACS, London 2008.

Contents

Introduction

ARGUABLY THE MOST ENIGMATIC ART MOVEMENT of the twentieth century, Surrealism had its official birth in 1924, heralded by the publication of the First Surrealist Manifesto. The roll call of signatories to the Manifesto, including leader André Breton, Louis Aragon, Antonin Artaud, Jacques Baron, Joe Bousquet, Jacques-André Boiffard, Jean Carrive, Rene Crevel, Robert Desnos, Paul Éluard, and Max Ernst, belies Surrealism's roots as a predominantly literary movement. Breton's definition of Surrealism as *"Psychic automatism in its pure state, by which one proposes to express—verbally, by means of the written word, or in any other*

manner—the actual functioning of thought" made clear that it could transcend genre and be interpreted in a variety of other forms. Throughout the 1920s, scores of visual artists allied themselves to the movement; with their involvement, Surrealism became a creative and cultural *tour de force*, its parameters repositioned within the visual arts, partially eclipsing its literary providence.

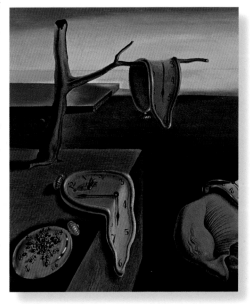

Surrealist artists can be loosely defined as one of two groups. The Automatists followed a Jungian

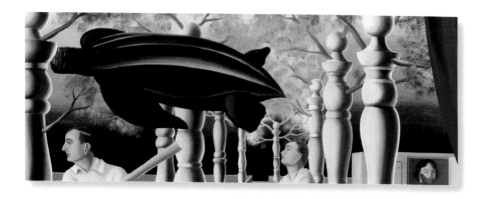

interpretation of the relationship between the unconscious and conscious mind. Applying the automatic writing techniques practiced by Breton and Éluard and applying it to their own expressive mark-making, these artists strived to allow images to form freely upon the canvas. In contrast, the Veristic Surrealists favoured a Freudian reading of the subconscious based upon the interpretation of dreams. Believing the image to be the language of the subconscious, these artists often created more formal works based upon their own dreams and hallucinations.

Surrealism was very much a product of its historic period; a reaction to, among other things, the devastation reeked upon Europe by the First World War, as well as recent innovations in the fields of art, literature, and science. As such, Surrealism cannot be considered within a vacuum. This volume aims to provide a snapshot of Surrealism's *oeuvre*; focusing, in the main, on painted works. Household names are represented alongside works by lesser-known artists. Some of the paintings reproduced here were created before the Surrealist Group's official foundation in 1924. Such works are included to demonstrate the debt to previous movements; among them the chaotic avant-gardism of Dada championed by Marcel Duchamp and Max Ernst, and the symbolic neo-classical absurdities generated by Giorgio de Chirico. Several pieces postdate the end of Surrealism's "golden epoch" in 1939. These later works are invariably contributions by American artists, and are testament to the dramatic rebirth of the movement in post-war America.

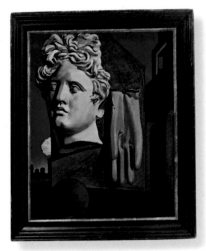

GIORGIO DE CHIRICO, 1888–1978

The Song of Love
1914, Museum Of Modern Art, New York

GIORGIO DE CHIRICO WAS AN ITALIAN PAINTER, raised partly in Greece, who studied in Athens and Munich before moving to Paris in 1911. His early works demonstrate that he was a skilled draughtsman, influenced by the architecture and sculpture of the classical age. The classical bust became a recurring motif; a focal point of *The Song of Love* is a marble head of Apollo, the patron of music, poetry, and medicine.

This painting is the best-known example of a body of work completed between 1913 and 1914, in which de Chirico launched a major development that would bring him to the attention of later Surrealist artists. The disembodied classical bust appears alongside disparate modern objects: a surgical rubber glove, a green ball, and, in the background, part of a steam train. The bust provides a

1911	1912	1913
Arrives in Paris to join his brother, the writer and musician Savinio.	Resumes painting after a long period of illness.	Exhibits at the Salon des Indépendants in Paris.

counterpoint to the modern, mundane objects within the frame, affecting both a sense of absurdity and cryptic unease within the composition.

This development was applauded by his friend, the celebrated writer and critic, Guillaume Apollinaire, who was the first to refer to de Chirico as a "metaphysical" painter. De Chirico's inspiration indeed owed much to the metaphysical philosophy. An avid reader of the German philosopher Immanuel Kant, he drew on his influential *The Critique of Pure Reason*, concluding that one's awareness of the world has its foundation as much in deductive or assumed experience as personal consciousness. To this end, he sought to lead his audience toward an awareness of relationships between seemingly unconnected matters.

De Chirico was also familiar with Sigmund Freud's theories of psychoanalysis. Under this influence, each object in the composition becomes symbolic, charged with associations both personal and universal. The train is a reference to his father's career as a railroad man, but is also chosen to provoke feelings of nostalgia in the viewer; in addition to providing a visual clue that identifies the bust as Apollo, the surgical glove represents the artist's own hypochondria, as well as a perception of a contemporary cultural malady, most likely the onset of World War I. Apollo's presence, and his implicit associations with literature and art as well as medicine, provides scope for the reading of the work as a confrontation between historical and modern ideologies, both cultural and scientific. The train, a symbol of modernity and momentum, provides a contemporary counterpoint to de Chirico's classical reference. Whether its track leads closer to or farther from the scene is unclear.

23¼ in (59 cm)

28¾ in (73 cm)

Fact

From 1919 de Chirico adopted an academic style, a development met with outrage by the Dada group, many of whom would become the Surrealists. From 1924 he was mocked in Surrealist magazines.

Oil on canvas

1914	1915	1919	1920
Completes and circulates *The Song of Love* as a woodcut.	Returns to Italy to complete his national service.	In Rome, begins painting in a traditional, academic style.	Abandons oil paint for tempera, heralding the end of his "great" period.

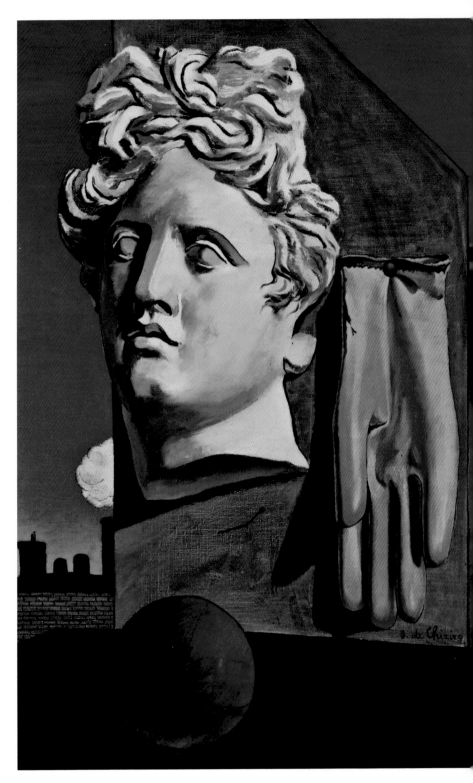

Most striking is the grouping of three incongruent objects: a bust of Apollo, a surgical rubber glove, and a green ball. These cryptic objects, in combination with an illogical sense of scale, remove the compositions from a recognizable reality. In common with earlier work, these artefacts are set amid a stark landscape featuring a distant horizon and near-cloudless sky, framing stark, geometric buildings that seem at once both classical and utilitarian. The placement of the bust and glove give the impression that a hand lies upon Apollo's unseen shoulder. This arrangement echoes the relationship between culture and science, a traditional theme with which de Chirico would have been familiar. Perched between two metaphorical giants, the ball becomes charged with the symbolism of an orb or globe.

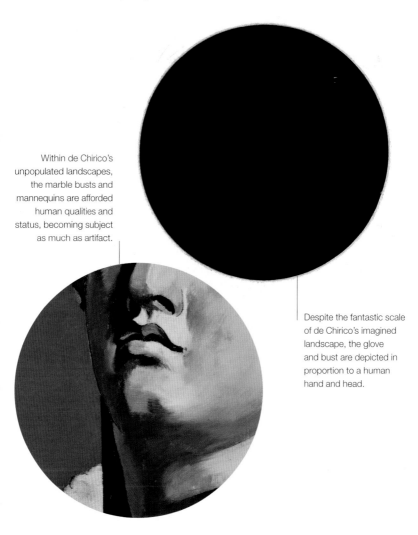

Within de Chirico's unpopulated landscapes, the marble busts and mannequins are afforded human qualities and status, becoming subject as much as artifact.

Despite the fantastic scale of de Chirico's imagined landscape, the glove and bust are depicted in proportion to a human hand and head.

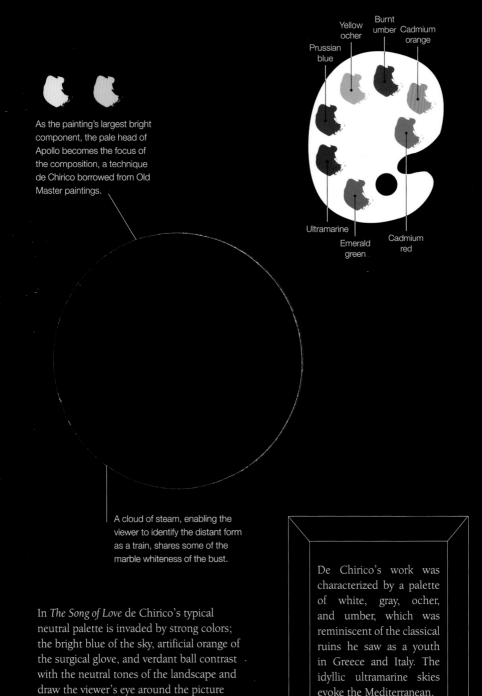

Prussian
blue

Yellow
ocher

Burnt
umber

Cadmium
orange

Ultramarine

Emerald
green

Cadmium
red

As the painting's largest bright component, the pale head of Apollo becomes the focus of the composition, a technique de Chirico borrowed from Old Master paintings.

A cloud of steam, enabling the viewer to identify the distant form as a train, shares some of the marble whiteness of the bust.

In *The Song of Love* de Chirico's typical neutral palette is invaded by strong colors; the bright blue of the sky, artificial orange of the surgical glove, and verdant ball contrast with the neutral tones of the landscape and draw the viewer's eye around the picture plane. The orange of the glove contrasts with the rich blue sky to achieve a sense of depth.

De Chirico's work was characterized by a palette of white, gray, ocher, and umber, which was reminiscent of the classical ruins he saw as a youth in Greece and Italy. The idyllic ultramarine skies evoke the Mediterranean.

De Chirico's academic training is evident in his rendering of the marble bust, which was an object traditionally copied by art students in lieu of a real human figure. He works lightly in oil paint from dark to light, carefully moulding highlights and shadows to create a sense of three-dimensional space. In the background, de Chirico uses paint sparingly, building the smooth sky from several washes, similar to the tempera washes he used later. The ocher buildings are composed in a similar way, although the finished surface is less uniform. These flat washes create a smooth, geometric setting that contrasts with the central object.

Strong, geometric shadows are achieved by layering translucent washes of ultramarine and burnt umber, through which the base color is visible.

During this period de Chirico worked only by artificial light, ensuring that shadows fell with consistency and geometric accuracy.

The rubber surface of the glove is achieved by layering cadmium red, orange, burnt umber and white oil paint onto the white ground of the canvas, creating a bright, synthetic surface.

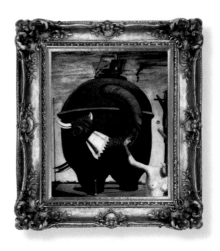

Celebes
1921, Tate Modern, London

CELEBES WAS THE FIRST LARGE-SCALE PAINTING by German artist Max Ernst, one of the first visual artists to join the Surrealist movement. The work has come to be known affectionately as "The Elephant Celebes," a reference to the fantastical creature that dominates the frame.

Ernst served in the German army during World War 1 and also formed an alliance with the Dadaist movement, founded in Zurich in 1916, which was known for its avant-garde anarchism, political commentary, and rejection of traditional standards and aesthetics in art. Later inspired by the momentum of Parisian Dadaism, Ernst was involved in founding the Cologne Dada Group in 1919. *Celebes* is, therefore, a significant work because it marks the transitional period between Dadaism and Surrealism.

1916	1918	1921
Participates in his first exhibition, in Berlin, while on military leave.	Returns to Cologne following the end of World War I.	Paints *Celebes* as a testament to his experience of war.

Several artists were associated with both movements, and Ernst was notable in his forceful support of each.

Ernst was fascinated by Sigmund Freud's theory of the unconscious and the method of free association used by the psychoanalyst to explore the unconscious mind of his patients. This interest in free association became the basis for what the Surrealists termed automatism. No preparatory work exists for *Celebes*, as Ernst allowed the composition and form to grow organically upon the canvas. What is known is that he took as his subject a nonsense rhyme, "The Elephant from Celebes," popular among German schoolboys, confirming his personal association with the tanks he experienced as a soldier and his childhood idea of an elephant.

Until 1921, Ernst worked primarily in collage, which he defined as "the exploitation of the chance meeting of two distant realities on an unfamiliar plane." He anticipated the aesthetic of the Surrealist movement by producing bizarre combinations of images. The use of disparate objects to fashion the elephantine form in *Celebes* echoes the techniques Ernst employed in his collages. The hulking mass that comprises the main body of the beast is based upon a photograph of a Sudanese grain store in an anthropological journal. Ernst has rendered the gray clay in metallic tones, lending a contemporary military aesthetic to the creation, but the sagging, undulating "flesh" above the creature's legs belies its organic origins.

Other, disparate objects include coiled tubing, some enameled coffee pots, and a metallic chimney stack. Curiously, the "head" from which horns protrude resembles a female mannequin, its breasts crushed flat.

42½ in (107.9 cm)

49½ in (125.4 cm)

Fact

Living in Paris without a passport, Ernst spent the early 1920s working in a bric-a-brac factory. This experience is thought to have inspired the curious juxtapositions of objects in his compositions.

Oil on canvas

1922	1924	1925	1926
Moves illegally to Paris, leaving behind his wife and child.	One of several artists to sign the First Surrealist Manifesto.	Develops the technique of frottage ("rubbing"), adopted by Surrealist automatist artists.	Writes the first of several theoretical texts on Surrealism.

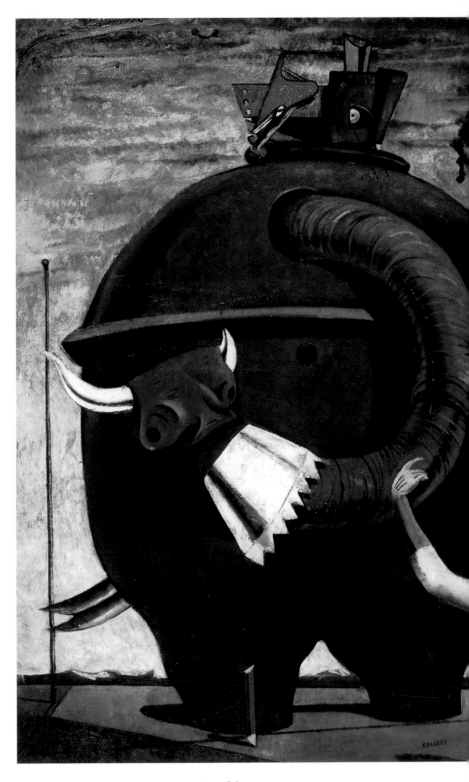

CALEBES

The picture plane is dominated by the hulking form of the "elephant," rendered in clean utilitarian lines against the textured sky. The relative solidity of the monster is undermined by two fish which, almost camouflaged, swim through the sky in the top left corner of the frame. Although recognizable as an elephant, the creature, a composite of near-familiar objects, defies certainty. A coiled tube protrudes from a hole in its upper section and leads to a horned head, creating a trunk of unspecified beginning and end, while a second pair of tusks protrude from its left side, suggesting the creature's head is in fact concealed from view. Disassociated objects share the frame and lend Ernst's dreamscape a nightmarish quality.

Cut off at the waist, a headless figure gestures in the foreground, creating a sense of space and action outside the frame.

The creature is reminiscent of a military tank, and the mechanical element on its back suggests the vehicle's gun turret.

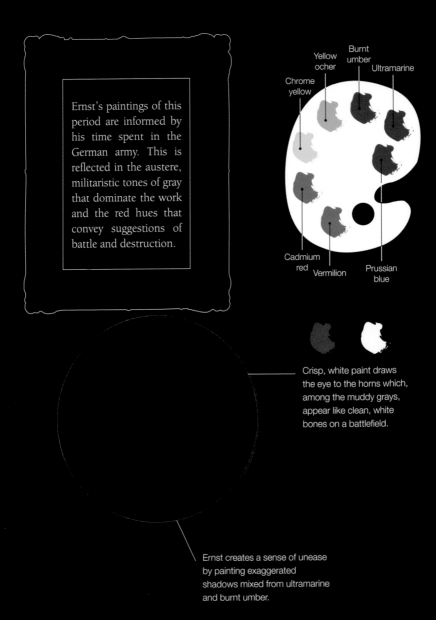

Ernst's paintings of this period are informed by his time spent in the German army. This is reflected in the austere, militaristic tones of gray that dominate the work and the red hues that convey suggestions of battle and destruction.

Chrome yellow

Yellow ocher

Burnt umber

Ultramarine

Cadmium red

Vermilion

Prussian blue

Crisp, white paint draws the eye to the horns which, among the muddy grays, appear like clean, white bones on a battlefield.

Ernst creates a sense of unease by painting exaggerated shadows mixed from ultramarine and burnt umber.

During this period Ernst was greatly influenced by Giorgio de Chirico, and here he uses de Chirico's motif of a broad expanse of graduated sky to create a sense of agoraphobia at odds with the oppressive, gray palette mixed from white, ultramarine, burnt umber, and yellow ocher. Cadmium red is used sparingly to highlight areas of the canvas, simultaneously balancing the composition by leading the eye away from the horned mask of the creature, the composition's natural focal point. The white skin of the figure in the foreground is mottled with delicate flesh tones, warmer than the rest of the composition. This hint of humanity, underscored by a red glove, separates her from the creature, casting her as a possible object of his menace.

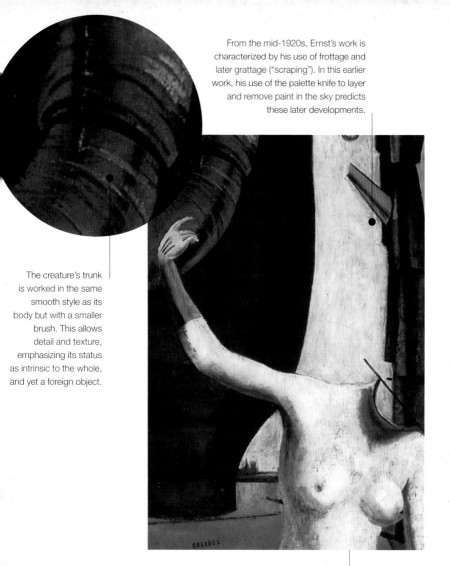

From the mid-1920s, Ernst's work is characterized by his use of frottage and later grattage ("scraping"). In this earlier work, his use of the palette knife to layer and remove paint in the sky predicts these later developments.

The creature's trunk is worked in the same smooth style as its body but with a smaller brush. This allows detail and texture, emphasizing its status as intrinsic to the whole, and yet a foreign object.

Ernst interrupts the tonal expanse of the canvas by using texture to define areas of the composition. The churning sweep of the sky is created by applying paint of similar tones with a palette knife. Loose brushstrokes form the fish in the sky, making them barely distinguishable among the angry clouds, yet encouraging the viewer to search for more concealed symbols. In contrast, the elephant is rendered in smooth, directional brushstrokes, the tones carefully blended to create a sense of three-dimensional solidity. The ground on which the creature stands is divided geometrically by shadows cast by unseen objects, and it is painted solidly and smoothly like the elephant's hide, grounding the creature and heightening the contrast between the middle ground and the sky.

The headless figure is shaped with a smaller brush than the elephant, creating an indistinct mottled surface that could be marble or lifeless flesh.

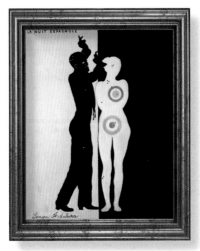

FRANCIS PICABIA, 1879–1953

Spanish Night
1922, Private Collection

AN IMPORTANT FIGURE THROUGHOUT THE EARLY TWENTIETH century, the artist Francis Picabia, born to a French mother and a Spanish–Cuban father, is best known for his association with the radical Dada movement that began in Zurich in 1916. More than just a painter, Picabia was also celebrated as a poet, theorist, and sometime anarchist. Fond of dancing and women, and interested in the writings of Friedrich Nietzsche, he drew interest and attention from the European and American avant-garde, producing imagery rich with erotic and dangerous possibilities. Fascinated, like Marcel Duchamp, by the relationship between technology and the human body, Picabia drew inspiration from sources as diverse as design blueprints, technical manuals, and popular magazines.

1913	1915	1917
Exhibits in New York; hailed as introducing modern art to America.	Begins working with pre-existing images, often industrial diagrams.	Begins publishing critical journal *391*. Publishes first poetry volume.

Spanish Night is executed in an ultra-modern, graphic style. It features a silhouette of a man and woman dancing flamenco, the mysterious, erotic dance of Spain that was at the time embraced by the European avant-garde. For Picabia, the flamenco motif marked the resurrection of an earlier fascination with the Spanish culture of his father; at the beginning of the twentieth century he had completed a large body of work celebrating Spanish life.

Under Picabia's experimental hand, the flamenco dancers are invested with deeper symbolism. Captured in silhouette, the couple are almost devoid of identities and thus endowed with a sense of mystery. Not unlike the mannequins favored by Giorgio de Chirico and popularized by Surrealism, the couple are reduced to cultural symbols. By adding painted bullet holes, Picabia emphasizes their two-dimensionality; the figures are dehumanized, becoming target-practice cut-outs, another motif adopted by Surrealist painters.

As well as preempting Surrealist concerns with reality and symbolism, *Spanish Night* marks an important chronological shift, emblematic of the demise of Dada in the early 1920s that made way for Surrealism. Dada was the training ground for many of Surrealism's key members, including founder André Breton, who was a vocal exponent of Dada until the early 1920s.

First exhibited in Paris at the Salon of 1922, then in the 1950s at a Dada retrospective curated by Duchamp, the painting was reproduced in 1923 as the front cover for Breton's short-lived journal *Littérature*. *Littérature* piloted ideologies that were later adopted in the First Surrealist Manifesto of 1924. Picabia's collaboration represents a work wedged between two ideologies, and the symbiotic relationship between the two movements.

59 in (150 cm)

73¾ in (186 cm)

Fact

Born into a bourgeois family, Picabia developed his love of modern machinery at a young age. He later spent much of his inheritance collecting vintage cars and yachts.

Oil on canvas

1918	1921	1922	1924
Invited to collaborate with the Dadaist movement.	Becomes close to Breton and his group, the Congress of Paris.	*Spanish Night* completed and exhibited in Paris.	Mocks Breton and Surrealism in the final issue of *391*.

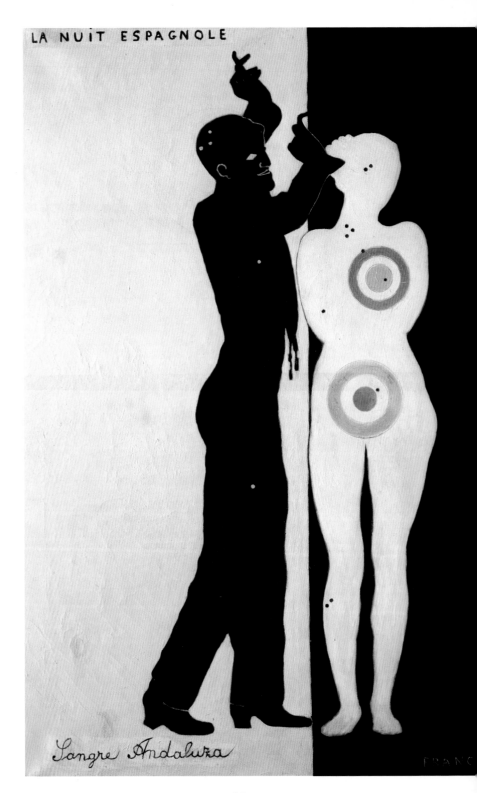

Symbolic of sexuality, strategically placed targets on the woman's torso suggest to the viewer an uneasy relationship between passion and peril.

Each figure protrudes subtly into the opposite space, undermining the composition's symmetry and drawing the eye to the negative spaces.

An imposing graphic work, Picabia has dissected the picture plane into black and white halves. The left-hand plane features the black silhouette of a male dancer; on the right the negative form of a female figure stands crisply against a black ground. The parallel arrangement of positive and negative serves as an easy visual metaphor for the stylized courtship expressed by the dance. The man is captured at a dynamic point in the ritual, his arms aloft, while the woman affects a passive display; even in silhouette her body is tense, as she turns defiantly from her suitor. A spattering of bullet holes amplifies the tension of the scene, while multicolored targets on the woman's torso mark the intended target.

The male dancer has crude facial features depicted in contrasting white paint. This addition implies the male gaze, testing Surrealism's voyeuristic fascination with the female form.

Picabia makes use of the social nuances (positive and negative) of black and white, casting the male figure as an ominous protagonist.

Naples yellow Yellow ocher Cadmium red

During this period Picabia was fascinated by diagrammatic drawings and instruction manuals, a visual reference reflected here in the dominant use of black and white. The monotone palette also amplifies the sensuality of the figures, part of a deeper exploration of the iconography of the dance; despite the warm, fiery tones usually associated with flamenco, the couple's pursuit is unmistakable. These warm tones are introduced in the form of two target motifs that relieve the black and white composition. It is notable that Picabia does not use the primary colors usually associated with targets, instead choosing shades of rose, cadmium red, orange, and yellow; although not explicitly symbolic, the positioning of the targets over the breast and womb afford connotations of femininity.

Picabia developed new styles at an astonishing rate, but during the early 1920s he focused on similar, monotone compositions, accentuated by three or four colors. He combined this limited palette with strong, geometric forms, which influenced the Op Art movement that reached its peak in the 1960s.

From a distance the edges of the targets appear soft and blurred. Picabia achieved this by stopping short of the pencil lines.

Picabia worked directly onto a white ground, first applying black paint to the male figure and background, then painting in the white areas. Details on the male figure's face and shoes were then completed. Small colored splashes on the canvas show that Picabia painted the target motifs last.

Expressive brushstrokes and layers of thick paint counteract the relatively monotone palette of *Spanish Night*; the entire impasto canvas reveals impulsive brushstrokes cascading in various directions. The visible strokes reveal that Picabia executed the canvas quickly, blocking in large areas with a thick brush, then using a smaller brush to finish outlines and areas of fine detail. Close up, it is possible to discern multiple areas of paint; the black background has been built up to an almost opaque finish, while the black figure is patchier, with its white ground still visible in some areas. The white paint is equally thick and rippling with texture. Soft, gray tones where the two shades meet show that the black areas were finished first.

A close look reveals that Picabia outlined the targets in pencil, probably using a pair of compasses, before the white paint was dry.

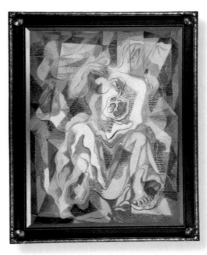

ANDRÉ MASSON, 1896–1987

Woman

1925, Private Collection

A SERVING SOLDIER DURING WORLD WAR I, André Masson was shot in the chest in 1917 at the Battle of the Somme. He suffered from trauma and depression throughout his life. Fascinated by the close connection between death and ecstasy that he had experienced when wounded, he charged his works with violent imagery, often uncomfortably combined with the erotic. An admirer of Friedrich Nietzsche, Masson shared the philosopher's belief that suffering and joy were part of the same condition.

Following the war, Masson settled in Paris, where his studio became the social center for a group of radical young artists and writers, including his neighbor, Joan Miró. At the time, Masson was working in a Cubist style, but a meeting with André Breton in 1924 led him to ally himself with the newly

1912

Studies at the Ecole des Beaux-Arts, Paris.

1919

Begins painting, having been released from hospital the previous year.

1920

Moves to Paris, where he seeks the company of artists and writers.

formed Surrealist Group. Under the guidance of the writers and artists of the group, Masson embraced the concept of automatism, popular among the movement's poets. He enthusiastically adopted and refined the technique of automatic drawing, allowing images to spring from unconscious mark-making, often produced in trances triggered by lack of sleep, starvation, or drugs. Most of Masson's automatic drawings are erotically charged, depicting sensuous, stylized nudes, although memories of war are often apparent, the two combining in a recurrent exploration of destruction and procreation.

With *Woman* Masson's earlier Cubist style is still evident in the way that he breaks down the composition into individual planes. In composition, the painting is almost identical to a more recognizably Cubist piece painted the same year, *Woman in a Garden*. Both feature a frontal view of a reclining nude surrounded by angular foliage and ripe fruits. It seems that *Woman*, which features the expansive, expressive marks peculiar to automatic drawing, was used as a study for the more refined Cubist piece.

In *Woman* Cubist angles cease toward the center of the frame; the planes of the woman's body are irregular, curving organically like the ripe, red fruits that droop from vines to her left. An open fruit is positioned upon her chest. The fruit's red flesh, segmented by white pith like a pomegranate, takes on the macabre appearance of exposed organs.

The combination of nude and fruit invites suggestion of a biblical reference, although Masson's fascination with classical mythology suggests the pomegranate form is more likely a reference to Persephone's time in Hades. Greek mythology is explored in many of Masson's later works, the Minotaur and its labyrinth becoming frequent motifs.

25 in (64 cm)

31½ in (80 cm)

Fact

Suffering from shell shock following his experiences in the trenches, Masson spent 1918 recovering in a French mental hospital. He was released in November, a few days before the Armistice.

Oil on canvas

1922

Gains reputation as a landscape painter and enjoys some commercial success.

1924

Meets Breton and joins the new Surrealist Group.

1925

A prolific year in which he completes *Woman*.

1926

His work included in the opening show of the Galerie Surréaliste.

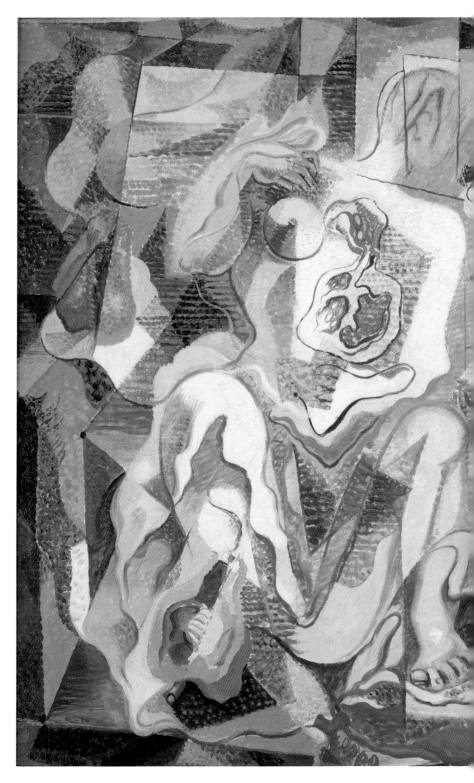

A large, female nude dominates the center of the composition. Her body is displayed to the viewer, but her head is turned to look over her left shoulder, obscuring her face. Abstract planes suggesting foliage intrude from the edges of the composition, the presence of strange fruit denoting the thick undergrowth as fruit trees. The fruits are large and misshapen, reminiscent of apples, pears, or even squashes. A strange form nestles on the woman's chest. Its stretched and bulbous shape resembles a halved fruit, sliced cleanly to expose white pith and red pomegranate-like seeds, but also internal organs. The biomorphic, organic shapes associated with automatism contrast with the angular planes of traditional Cubist composition.

A nude in a garden invites biblical interpretations, but the woman's hair, cropped short in the fashion of the day, implies modernity.

The female form is constructed from undulating, indistinct planes, with the exception of the right breast which is spherical and geometric.

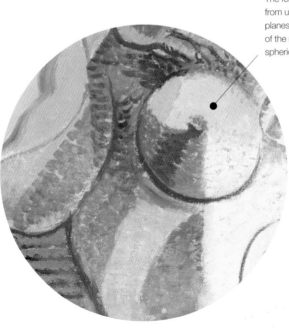

The blues and purples of the shadows are the coolest tones present. These cool tones recede, allowing Masson to indicate depth.

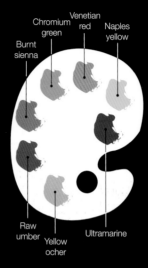

Chromium green

Venetian red

Naples yellow

Burnt sienna

Raw umber

Yellow ocher

Ultramarine

Red and green are complementary colors. Their presence provides a contrast to the brown tones and enlivens the composition.

Masson has limited his palette to neutral brown and creams, mixed from white, yellow ocher, burnt umber, raw sienna, and black. These earthy tones were widely associated with the Cubist style, but are augmented with areas of green, red and, in the shadows, muted purples. The red and green tones are derived from the fruits depicted to the left of the picture plane; Masson uses red to draw the viewer's eye across the canvas and highlight key areas. The figure and the foliage are rendered in similar shades, underscoring the relationship between the nude and nature, although the nude is defined by large, pale highlights mixed from white and yellow.

During the 1920s, Masson was influenced by the Cubist paintings of Pablo Picasso and Georges Braque, adopting their natural, muted palettes. By 1925, he was using primary colors to enhance his compositions, and continued to experiment with brighter shades.

Automatic drawing formed the basis of Masson's composition. This expressive, loose technique is echoed by the way he handles the paint, building up areas of texture and defining shapes with deft, flowing brushstrokes. The painting consists of contrasting areas of thick and thin paint; on the woman's head, for instance, areas of bare canvas and the original underdrawing remain visible. Such areas provide clues to Masson's technique, revealing that, employing his automatist techniques, he drew straight onto the canvas, allowing these marks to shape the composition. It also shows that he worked straight onto the primed white of the canvas, rather than applying the darker ground that was traditional in oil painting. Painting onto a white surface heightens the intensity of colors.

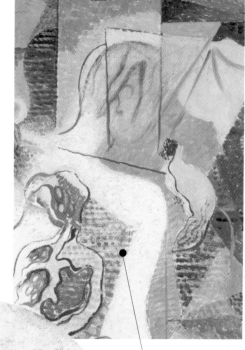

Masson suggests the hair and ear of the seated nude with a few, fluid lines, achieved using a fine brush and diluted paint.

Masson constructed tone and texture using a Pointillist technique, in which small dabs of paint of different colors are layered together.

Masson uses paint to accentuate the graphic, angular, Cubist planes within the composition. Pointillist dabs of paint form tonal horizontal stripes. These formal elements are intended to contrast with the automatist components of the composition.

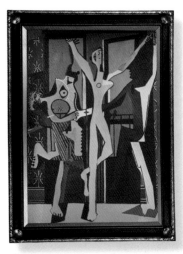

PABLO PICASSO, 1881–1973

The Three Dancers
1925

ALTHOUGH NOT A FORMAL MEMBER OF THE Parisian Surrealists, Pablo Picasso was greatly admired by, and close to, the group. Soon after its completion, *The Three Dancers* was reproduced in the journal *La Révolution Surréaliste*, securing its reputation as the Spanish artist's "great" Surrealist work. Painted during a period when he was creating works simultaneously in two very different ways, both Cubist and Neoclassical in style, *The Three Dancers* is thus of great historic importance, demonstrating an early amalgamation of both styles. It also marks a new emotional, sometimes violent, aesthetic in Picasso's work, represented by the expressive distortion of the female form.

The theme of the three dancers was assumed to have been based on Sergei Diaghilev's company Ballets Russes with which Picasso's then wife,

1900	1901	1914
Picasso's first stay in Paris, which led to Casagemas' suicide.	Following Casagemas' suicide, Pichot and Germaine marry.	In Rome designing sets for the Ballets Russes; meets Russian ballerina Olga Koklova.

Olga Koklova, was a dancer. X-rays have shown that a far more conventional composition featuring three ballerinas lies beneath the finished canvas.

Picasso attached great importance to the painting, refusing to part with it despite many offers. It was not until 1965 that he spoke about the work for the first time. According to him, the painting as we see it today was motivated by the death of a friend, the Spanish Impressionist Ramon Pichot. In 1900 Pichot had been involved in a love triangle comprising their mutual friend, Carlos Casagemas, and a Parisian woman named Germaine, which led to Casagemas' suicide in 1901. Pichot and Germaine then married. Since these revelations, the painting has generally been explained as an impression of the affair, with the crude, grotesque figure to the left symbolizing Germaine, and the silhouetted figure on the right, including the background black head, representing Pichot. The central figure, splayed in a parody of crucifixion is, then, Casagemas, caught like a rag doll between the two lovers. There is a twofold problem with this interpretation: Picasso's anarchic reputation for intentionally obscuring the meaning of his works; and the decidedly female physique of at least two of the figures.

Other interpretations have denoted the work as a depiction of love, sex, and death, fueled by an unhappy period in Picasso's marriage. In the background to the right of the frame, a male figure in black appears in profile. As noted, this visage is commonly described as the head of Pichot and treated as part of the rightmost dancing figure. In fact, it is a distinctive motif that reoccurred the same year in Picasso's portrait of his wife entitled *La Statuaire*.

56 in (142.2 cm)

85 in (215.3 cm)

Fact

Even as a child Picasso demonstrated precocious talent as a painter. At thirteen he had his first one-man show—in the back room of an umbrella shop in Malaga.

Oil on canvas

1918	1925	1925	1965
Marries Olga Koklova.	Completes *The Three Dancers* in Paris.	*The Three Dancers* is reproduced in the July edition of *La Révolution Surréaliste*.	Offers his first and only explanation of the painting.

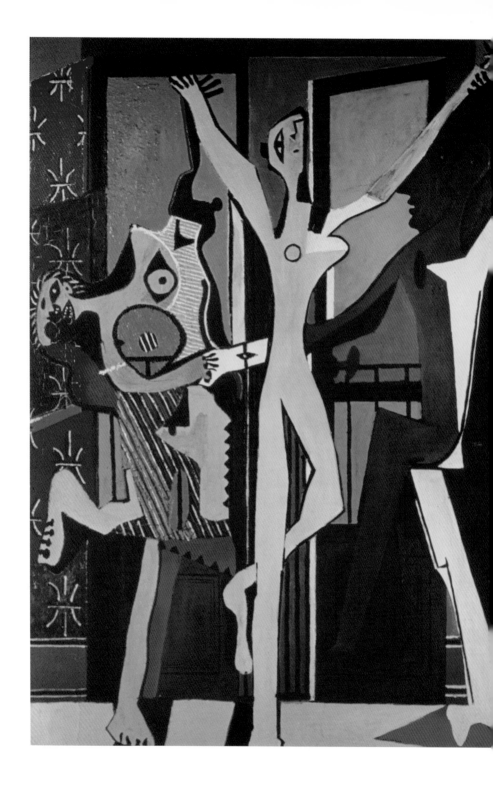

The Three Dancers is a highly abstracted scene showing three distorted figures dancing before a set of French windows. The view beyond the balcony featuring sea, sky, and sandy cliffs could be based on the coast at Monte Carlo, where Picasso had spent time while working on the painting. The most striking figure is the female form to the left of the picture plane, arching her back in a wild dance as she bares her carnivorous teeth. The woman's face is known to be based on a tribal mask from New Guinea owned by Picasso. The artist associated primitivism with sexuality, and, as if to heighten this association, he depicts the figure's genitals, enlarged and suspended on the outside of her skirts.

The pale, slender, central figure, her arms outstretched, dissects the space, emphasizing tension between the two halves of the picture plane.

The viewer's eye is drawn to the comparatively simple central figure, marking her as the scene's protagonist and narrative focal point.

Picasso manipulated his forms by painting exaggerated shadows in heavy black paint; here a breast is transformed into a strange, staring eye.

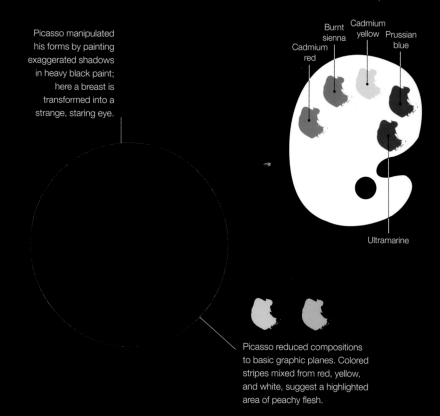

Cadmium red

Burnt sienna

Cadmium yellow

Prussian blue

Ultramarine

Picasso reduced compositions to basic graphic planes. Colored stripes mixed from red, yellow, and white, suggest a highlighted area of peachy flesh.

Much of the interior scene is dominated by areas of black, burnt umber, and white, providing an austerity to the space that is offset by contrasting fields of vermilion. Even the flesh tones of two of the figures are mixed from vermilion and white, with a little raw sienna, resulting in crude pink skin that casts the characters as caricatures. Swathes of cobalt blue and ultramarine denote the sea and sky of the outside world, creating an uneasy sense of it being both day and night. In the foreground, a lone block of raw sienna hints at a light spilling through the French windows and across the floor. Planes of color are separated by graphic black outlines.

Other works that Picasso produced during 1925 feature figures with the same synthetic pink skin, offset against black, white, brown, and blue. Although he was a master of color, as earlier works attest, Picasso adopted an increasingly limited palette throughout the decade.

Picasso has painted over another version of the composition, meaning that the paint is necessarily thick and opaque. The abandoned image is still evident in places; an area of impasto covers the left-hand glass of the French doors and spills onto the dark window frame, suggesting an earlier figure obliterated by paint. Picasso often executed paintings quickly, in as little as a day. Although it is thought that *The Three Dancers* was painted over a much longer period, possibly between March 1925 when Pichot died and July 1925 when it was reproduced in *La Révolution Surréaliste*, the physical actions of his impassioned painting are visible in the changing directions of the brushwork and the density and flow of the paint.

Picasso suggests human features and emotion in a few simple lines. Here, an expressive upraised chin and facial features are easily recognizable.

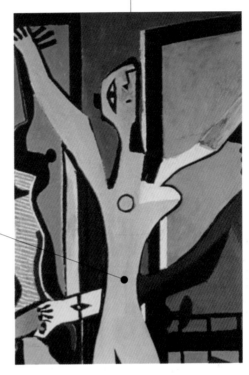

Picasso often reused canvases, believing that the destruction of an old work was intrinsic to the creation of the new. He did not cover old work with a new white ground, but worked straight onto the oil paint, often leaving specks of color visible or, as here, areas of textural impasto.

A thin, loosely applied layer of ultramarine paint masks a coat of cobalt blue below. Visible brush marks trace Picasso's bold and expressive strokes.

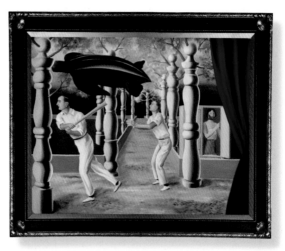

RENÉ MAGRITTE, 1898–1967

The Secret Player
1927, Musees Royaux des Beaux-Arts, Brussels

THE BELGIAN PAINTER RENÉ MAGRITTE STILL ENJOYS a reputation as one of the best-known artists of the Surrealist movement. *The Secret Player* was completed in Paris during one of Magritte's most prolific periods. Between 1926 and 1927 he was reported to have completed one painting per week, sixty-one of which were shown at the Galerie Le Centaure, Brussels, in the winter of 1927. This painting is thought to have been among them.

The Secret Player is characterized by an irreverent, dreamlike quality, in which real objects and individuals interact within an imagined space. Magritte is famed for choosing cryptic names for his works and the identity of the "secret player" is typically obscure. The viewer surveys the scene from behind a dark red curtain, like those used in theaters, visible to the right of the painting.

1916	1922	1926
Attends Académie des Beaux-Arts in Brussels until 1918.	Marries, and takes work as a graphic artist.	Completes his first surrealist work, *The Lost Jockey*, in his spare time.

Magritte was fascinated by the boundary between reality and fantasy, a preoccupation that informed his considered, Realist style. He professed to have an "obsession with the hidden," stating that *"Everything we see hides another thing, we always want to see what is hidden by what we see."* The curtain is symbolic of this conviction; it separates the scene from reality, while suggesting the simplicity with which the hidden can be exposed.

Magritte used this conceit several times in his early career; in his first surrealist work, *The Lost Jockey*, the scene is framed by a similar curtain. He first used the motif of hybrid trees, their trunks formed from wooden balustrades reminiscent of chess pieces, in the same work. Such hybrid objects were to make frequent appearances throughout the artist's career; in later works, shoes sprout human toes and breasts grow from women's nightgowns. Such conceits are both visual puns and metaphors for "the hidden."

The darkest element of the work is the gagged woman encased in a small wardrobe to the right of the picture plane. Bondage, in various guises, is depicted by the Surrealists, underscoring their collective interest in the Marquis de Sade, whom they applauded in the First Surrealist Manifesto as "surrealist in his sadism." This subtle sadomasochistic reference jars with the youthful naivety that is implied by the rest of the composition. Its presence is a reference to the confusion of dreams and the surrealist belief that the subconscious has erotic desire as its basis. The gag becomes a distinct metaphor for the suppression of desire by the conscious mind.

77 in (195 cm)

60 in (152 cm)

Fact

Magritte held strong left-wing views, briefly joining the Belgian Communist Party in 1932. He submitted several posters for use by the Party, all of which were rejected by its leadership.

Oil on canvas

1927	1927	1929	1930
First exhibition at Le Centaure, Brussels.	Leaves Brussels for Paris where he paints *The Secret Player*.	Becomes disillusioned with the Surrealist group, criticizing Dalí's hallucinatory methods.	Ceremonially burns any artefacts that remind him of the Surrealist Group.

Two baseball players await a ball from beyond the picture plane, while a leatherback turtle swims lazily above them, its head partly obscured by one of several oversized, turned wooden spindles that dominate the composition. These balustrades sprout branches of pink blossom, forming an avenue of mutant trees, leading the eye from foreground to background. The proportions of these forms are subtly altered, several assuming the curves of an hourglass figure. These pale, limbless forms seem to simulate not just generic female bodies but the mannequins that had become staple motifs in the work of many Surrealist artists. These human attributes cast the figures as the impassive chess-piece guards of a gagged woman imprisoned to the right of the picture plane.

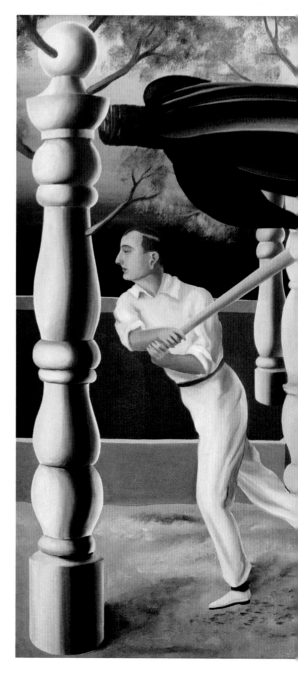

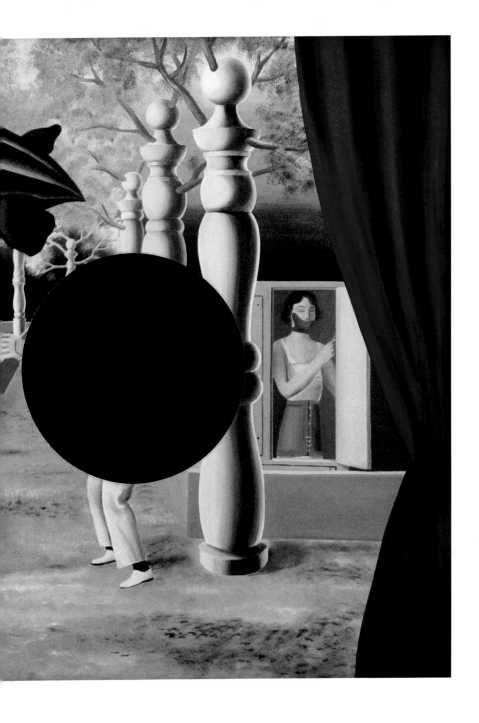

While working as a wallpaper designer in 1922, Magritte saw a reproduction of Giorgio de Chirico's *The Song of Love*. He later claimed that the piece inspired him to become a painter. Like de Chirico, Magritte has chosen a restricted palette, employing neutral tones of white and gray, mixed from white, cobalt blue, raw umber, and black, with occasional touches of red. To the right of the frame is a curtain painted in a rich tone, possibly Venetian red; the same pigment is used to mix cool, pink tones within the main composition. The imprisoned woman deviates from this color scheme, the warm vermilion of her skirt signaling that she is other, removed from the scenario that is unfolding.

Few objects deviate from Magritte's cool palette; those that do are decidedly mundane, including a baseball bat in ocher tones.

The clean, white uniforms of the baseball players contrast with the dominant gray tones, making the figures the focus of the composition.

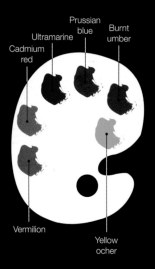

Cadmium red

Ultramarine

Prussian blue

Burnt umber

Vermilion

Yellow ocher

As opposed to the imagery of magic and hallucination from which other Surrealists drew inspiration, Magritte looked for the relationship between the uncanny and the everyday. A naturalistic palette underscored his belief that the imagination created fantasy from what it knew to be real.

Like de Chirico, Magritte models his forms carefully, using a flat brush. Unlike the older artist, Magritte alters his technique to achieve greater depth of field; the most detailed elements of the painting are the blossoming branches dominating the upper part of the canvas. As they recede, the brushwork becomes looser and more impressionistic.

Oil painters work from dark to light. A close-up look at the canvas shows that the highlights are the thickest areas of paint.

Most oil painters prepare their canvas with a dark wash, but Magritte painted onto a white ground to preserve the luminosity of his paint.

Magritte has adhered to the rules of academic composition taught by such establishments as the Brussels Académie des Beaux-Arts. A meticulous draughtsman, he based his paintings upon carefully measured underdrawings. The geometric construction of the background allows for a realistic perspective, achieved by meticulous observation and measurement. The avenue that divides the picture plane flows toward an invisible vanishing point in the center of the canvas.

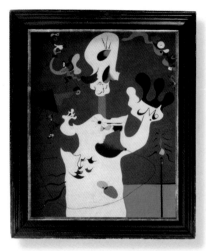

JOAN MIRÓ, 1893–1983

The Potato

1928, Metropolitan Museum of Art, New York

HAILING FROM THE CATALONIA REGION OF NORTHEASTERN Spain, Joan Miró is one of Surrealism's most iconic members. A critic of traditional painting practices, he is known for his inventive, experimental style and prolific output. Miró left Barcelona in 1920, settling in Paris during a vibrant and important time. He quickly became associated with André Breton's Surrealist circle and was involved with the group from its inception, although he was not a signatory of the First Manifesto of 1924. *The Potato* remains one of Miró's best-known Surrealist paintings; combining playfully distorted forms with a seemingly nonsensical title, the work exhibits the painter's trademark primary colors, organic shapes, flattened forms, and compositions at once naïve and complex.

1915

Introduced to the poetry of Apollinaire as a student.

1919

Spends six months in Paris where he meets Picasso.

1920

Moves to Paris, becomes a close associate of Breton's circle.

Through his involvement with Surrealism Miró refined his style, drawing on the popular Surrealist techniques of free invention and automatism that encouraged artists to work spontaneously, often in reaction to a single blot of paint upon the canvas. He described the beginning of a painting as follows: *"Rather than setting out to paint something, I begin painting. As I paint the picture begins to assert itself under my brush. The form becomes a sign for a woman or a bird as I work ... the first stage is free, unconscious."* As Miró's example suggests, women and birds were recurring themes in his work, symbolic of renewal and procreation; his distorted women, like the figure in *The Potato*, often feature exaggerated breasts and sexual organs.

Miró successfully united two key concerns of the Surrealist movement, by combining automatist techniques with personal, symbolic imagery drawn from his dreams; the humanoid figures scaling the left-hand side of *The Potato* are motifs that recur in his paintings.

Unlike many Surrealists, Miró was not in awe of the psychoanalytical theories of Sigmund Freud and Carl Jung. Instead, he drew inspiration from poets associated with the group, Guillaume Apollinaire, in particular, with whom he collaborated before the poet's death in 1918. Miró produced illustrations for his poetry, and sometimes incorporated lines of text in his paintings. As one of Breton's inner circle, Miró was involved in the Surrealist game of "Exquisite Corpse," by which members created collaborative poems or drawings, each supplying a single word or element, often folding the paper to hide the new addition. The finished products were the result of chance, and the group delighted in the uncanny or fantastical results; they are thought to have informed the imagery in many of Miró's paintings.

32 in (81.6 cm)

40 in (101 cm)

Fact

As a student, Miró began a series of sensory experiments, drawing objects from touch instead of sight. The resulting drawings had a great stylistic impact on his later work.

Oil on canvas

1923	1927	1928	1929
Adopts an abstract style; produces paintings based on poems.	Begins body of figurative works based on Catalan folk art.	Completes *The Potato*.	Begins long period experimenting with techniques including collage and assemblage.

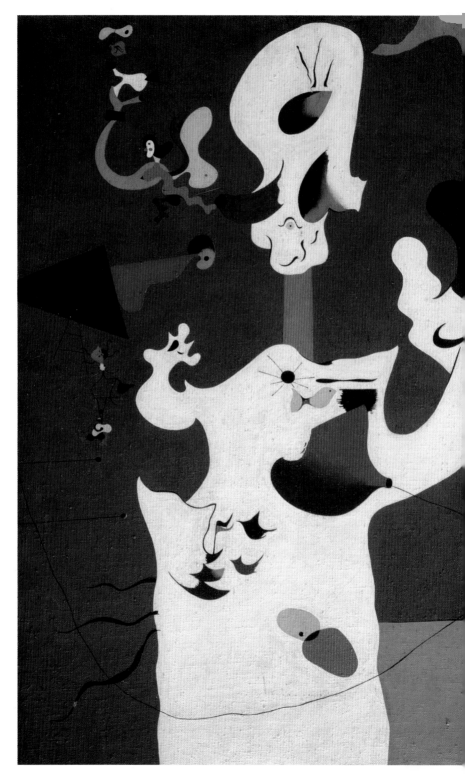

The composition is dominated by a huge human form, its arms outstretched. On its chest sits a large brown breast, marking the figure as female. A fine black thread shoots from the breast and forms an inverted arc between the right and left of the picture plane. This arc completes an oval of activity that surrounds the figure, crowding the top half of the canvas. Hybrid creatures circle the figure, while insect-like forms smile as they climb a spindly ladder suspended in mid-air. A sputtering wand, resembling an oversized matchstick, is thrust into the foreground. The scene is set against a deep blue background. A patch of yellow ocher to the right is thought to represent a potato field.

A red post where the figure's neck should be is reminiscent of a scarecrow, so testing the boundary between abstraction and illusion.

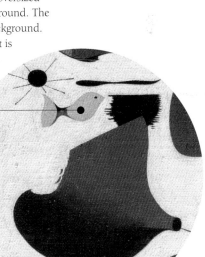

Fish appear frequently in Surrealist works and are almost always depicted out of water, suggesting an illusory landscape.

Warm yellow ocher and orange tones contrast with the cool blue background, giving an impression of depth, despite the objects' flat surfaces.

When isolated, the seemingly abstract forms on the painting's peripheries visually realign, often taking on figurative qualities.

Throughout his career, Miró drew inspiration from the bold, primary colors and simplified forms that were typical of local decorative arts in his native Catalonia. He was fascinated by wall paintings featuring colorful, crude figures that decorated the area's ancient churches.

Burnt sienna

Burnt umber

Yellow ocher

Cadmium red

Bright green

Ultramarine

The canvas is dominated by an intense layer of Prussian blue, a color that Miró associated with dreams. Its presence confirms that *The Potato* is one of Miró's many "dream paintings" produced during the late 1920s. The Prussian blue is offset by pure white and a rich mustard mixed from yellow ocher. Black, vermilion, brown, and green are used sparingly. Although not thought to be symbolic, Miró associated these colors with his youth in Catalonia. The colors are positioned to achieve visual balance; the ocher expanse at the bottom of the picture plane is echoed by flowing ocher shapes at the top, while a black triangle on the left is in counterpoint to the large, dark fingers of the right hand.

Unlike other artists employing automatist techniques, Miró worked in a slow, controlled manner. Despite claims of spontaneous creations, evidence suggests that he produced many drawings and studies in preparation for each painting, gradually refining the abstract forms he produced into considered shapes. Professing as a young man a desire to "murder" traditional painting, Miró developed a unique system that transformed his picture plane into a series of flattened, graphic forms. He worked onto primed canvas without underdrawings and applied colors methodically, allowing each layer of paint to dry in order to retain the purity of every color. The flat surface is achieved by building up thin layers of paint with a small brush. Occasional areas of impasto suggest overpainting.

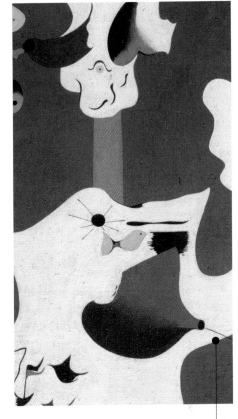

On occasion, Miró hinted at three-dimensional forms by blending two or more colors within a single graphic form.

Miró added detail and definition in black with a fine brush. These details, like the fine thread protruding from the breast, were added later.

Miró probably began the painting by applying an ocher ground; specks of the color are visible beneath the blue paint of the background, while several forms are surrounded by subtle yellow outlines. The blue background appears to have been painted last.

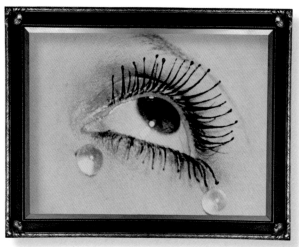

Tears

c. 1930

ALTHOUGH BEST KNOWN FOR HIS PHOTOGRAPHY, MAN RAY began his career as a painter, and maintained throughout his life that he was not a photographer, but an artist who used photography as a means of research. He often claimed to have taken up photography, in about 1916, through necessity, having become dissatisfied by the reproductions of his paintings made by professional photographers. In an interview conducted shortly before his death, Man Ray revealed that his photographic skills were honed during a few short months of study and experimentation, after which: *"Instead of painting I began to photograph people and I didn't want to paint portraits any more. If I painted a portrait, I wasn't interested in making a likeness, or even a dramatic thing. I finally decided there was no comparison between the two, photography and*

1916	1921	1925
Takes up photography.	Moves from New York to Paris, where he remains for 20 years.	Exhibits photography at the first Surrealist Exhibition, Paris.

painting. I paint what cannot be photographed, something from the imagination, or a dream, or a subconscious impulse. I photograph the things that I don't want to paint, things that are already in existence."

The fantastical role that Man Ray defined for painting resonates with Surrealist dogma. The revelation is in line with two essays published several years before: Photography is not Art (1943) and Art is not Photography (1960). In the latter, he wrote: *"Painting has been liberated from its purely anecdotal and functional role, and, thanks to photography, it has never been so creative as during the last two generations. At the same time, photography, which was initially considered as a scientific and documentary medium, is also liberated from its strictly utilitarian function."*

Throughout his career he successfully invested the most everyday of objects with narrative and gravitas. By cropping images, as in *Tears*, he removed objects from their familiar context, achieving a sense of the uncanny and forcing the viewer to re-evaluate the subject. Man Ray considered *Tears*, often known as *Glass Tears*, to be one of his most successful photographs. He reused this extraordinary motif in other photographs throughout the 1930s, and included it as the first plate in a 1934 book of his work, alongside the words, *"A dancer's make up brought fourth these (glass) tears that do not express any kind of emotion."* The teardrops to which the title refers are indeed glass beads, popularly used by dancers to signify real tears. All that is known about the model is that she was a Parisian cancan dancer.

11¾ in (29.8 cm)

9 in (23 cm)

Fact

Another version of Tears, showing a larger area of the model's face, sold for $1.3 million dollars in 1999; at the time, this was the highest sum ever paid for a photograph.

Gelatin silver print

1930	1934	1940	1941
The photo-shoot for *Tears* is thought to have been executed.	*Tears* published twice, in Minotaure and a book of Man Ray's photographs.	Returns to the United States following the outbreak of war.	Begins working as a fashion photographer for *Vogue* and *Harper's Bazaar*.

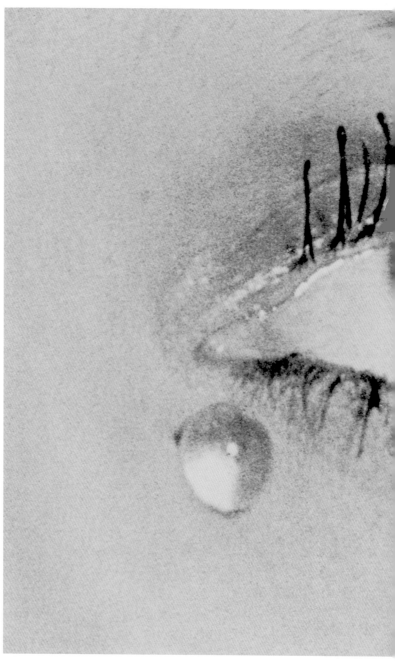

Tears is a detail from a larger photograph. In 1934, an uncropped print from the session was reproduced in the French journal *Minotaure*. It shows the dancer seated on the floor, her head tilted to the left. Another well-known version of *Tears* shows both the model's eyes. It is clear that the eye, with heavily made-up lashes, is the dancer's left eye, although Man Ray has

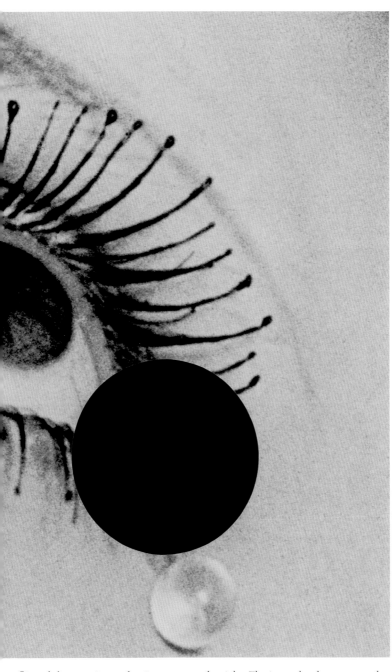

flipped the negative so that it appears as the right. The image has been cropped so that the iris is at the center of the composition. The elongated upper lashes each almost to the top of the picture plane, but are balanced by the detail of the globular glass "tears."

Gelatin silver prints are the most usual means of making black-and-white prints from negatives; paper is coated with a layer of gelatin that contains light-sensitive silver salts. Developed in the 1870s, gelatin silver prints created stable, long-lasting black-and-white images that did not yellow with age. The technique remains the most widely used to this day.

Man Ray developed his own photographs and spent many hours in the darkroom experimenting with various exposure and development times. It was during one of these sessions that he exposed a developing image to the light and chanced upon a technique known as solarization, which created dark halos on the image and intensified areas of dark and light.

Man Ray's conversion to photography came as panchromatic printing techniques were being perfected, allowing a greater variety of tonal variations than ever before.

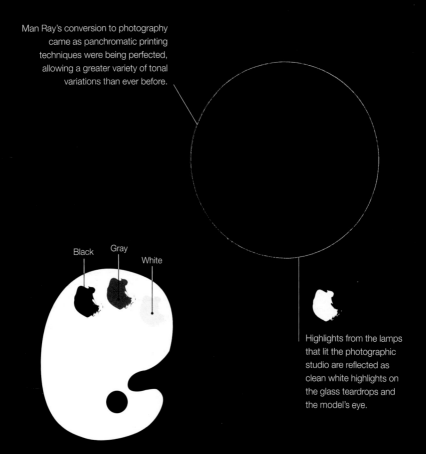

Black Gray

White

Highlights from the lamps that lit the photographic studio are reflected as clean white highlights on the glass teardrops and the model's eye.

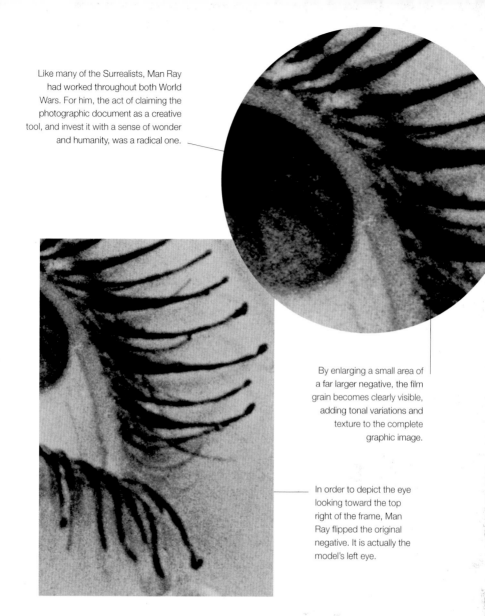

Like many of the Surrealists, Man Ray had worked throughout both World Wars. For him, the act of claiming the photographic document as a creative tool, and invest it with a sense of wonder and humanity, was a radical one.

By enlarging a small area of a far larger negative, the film grain becomes clearly visible, adding tonal variations and texture to the complete graphic image.

In order to depict the eye looking toward the top right of the frame, Man Ray flipped the original negative. It is actually the model's left eye.

Although famed for creating some of the most iconic photographs of the twentieth century, Man Ray made use of extraordinarily simple techniques and equipment. He usually worked with a modest 35 mm Kodak camera, producing standard rectangular negatives, which he then cropped, focusing on select elements within the frame. He was fascinated by the interplay of light and shadow in his images but lit his compositions simply, often using ordinary domestic light bulbs. Despite claiming that photography was the *"final art, demanding no effort but that of living and waiting,"* sitters often commented on the painstaking precision with which he worked.

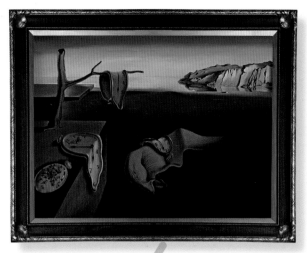

The Persistence of Memory

1931, Museum Of Modern Art, New York

HAVING BEEN INTRODUCED TO THE PARISIAN SURREALISTS in 1928, the eccentric Salvador Dalí joined the movement in 1929 and quickly became the most recognizable figure of Surrealism. His distorted paintings have achieved iconic status around the world; *The Persistence of Memory*, depicting flaccid pocket watches, wilted on a deserted beach, remains one of the best known. The work was first exhibited in 1932 at a Surrealist retrospective in New York. It was the first time Dalí had shown his work in the United States, the country where he would live out World War II.

Like most Surrealists, Dalí was an avid follower of Sigmund Freud and the theories of the subconscious that he set out in *The Interpretation of Dreams*. He sought to meet Freud on several occasions, eventually traveling to London

1922	1925	1927
Studies the Old Masters at the Real Academia de Bellas Artes in Madrid.	First solo exhibition in Barcelona.	Called up for service in the Spanish military.

in 1938 for an audience with the father of psychoanalysis. Inspired by the relationship between dreams and reality, Dalí referred to *The Persistence of Memory*, which was informed by visions experienced during self-induced psychotic hallucinations, as a "hand-painted dream photograph."

Dalí's hallucinatory methods were staunchly criticized by René Magritte, who had spent a long period in Spain with his colleague in 1929. Despite their differences, similarities are apparent in the two artists' exploration and portrayal of the relationship between fantasy and reality. Like Magritte, Dalí recognized that fantasy was at its most sinister when combined with the rational, and strove to employ "the most imperialist fury of precision" in his paintings. As a result, even the most grotesque imaginings remain recognizable and are rendered with what has been described as photographic clarity. Stylistically, the Old Masters, particularly Francisco de Goya, are evident in Dalí's *oeuvre*.

From the beginning of his career Dalí enjoyed celebrity status, and had become a household name in Europe and the United States by the 1940s. A grand self-publicist, he frequently placed himself at the center of even the most lurid visions; the distorted head in *The Persistence of Memory* is based on Dalí's own facial features, while the scene unfolds before golden cliffs, recognizable as the coast of his homeland, Catalonia.

Dalí's distorted head appears in other paintings; its shape is thought to be based on a rock he found on a beach. The transformation of an inanimate object into a human head is an example of the subconscious associations that the artist sought to examine in his work. Similarly, the motif of melting clocks is said to have been inspired by a Camembert cheese that Dalí left in the sun.

13 in (33 cm)

9½ in (24 cm)

Fact

In 1934 Dalí was put on "trial" and ceremoniously expelled from the Surrealist group after members took offence at a work depicting Lenin, entitled The Enigma of William Tell.

Oil on canvas

1928

Collaborates with Luis Buñuel on the film *Un Chien Andalou*.

1928

Visits Paris and is introduced to Dadaist and Surrealist artists by Joan Miró.

1929

Joins the Surrealist movement.

1931

Completes *The Persistence of Memory*.

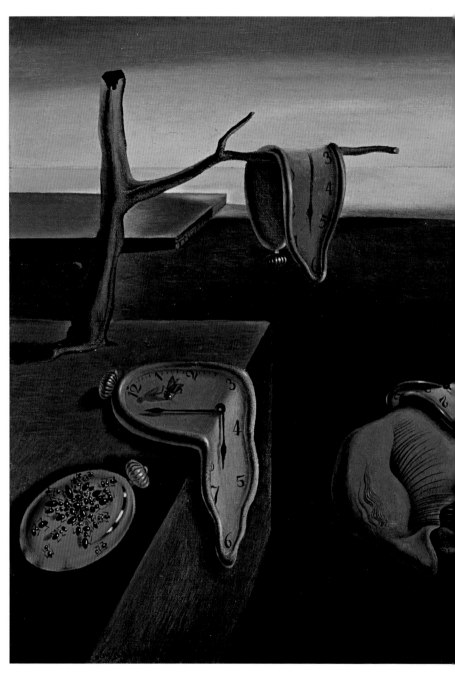

Three wilted clock faces hang limply in the foreground as if melted. To the far left of the frame is a brass pocket watch, not under attack from the hot sun, but from a swarm of ants, which cluster in its center, as if feeding on its shiny surface. Dalí used ants as a metaphor for decay in several works, including the film *Un Chien Andalou*.

The ants are not the only symbol of destruction. Dalí knew of Albert Einstein's theories of relativity, and it has been suggested that the melting clocks depict the distortion of time by gravity as a metaphor for the threat of war during the 1930s. The barren tree on the left mimics that from Goya's *Disasters of War* etchings, on which a human head is impaled.

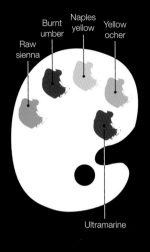

Raw
sienna

Burnt
umber

Naples
yellow

Yellow
ocher

Ultramarine

Dalí unsettles the viewer by casting some areas in the painting, such as this clock face, in inexplicable shadow, making the light source uncertain, and therefore alien.

The calm sea, painted in pale blue, mirrors the face of the clock in the foreground and balances the composition, while leading the eye around the canvas.

No matter how fantastic his visions were, Dalí usually rendered them in vivid, naturalistic tones. Scenes are played out amid large expanses of ocher desert sand and beneath a bright blue sky, but he cleverly manipulates both light and

In the hands of Dalí the unassuming blues and yellow that dominate the canvas seem sickly, and take on a sinister air. In a challenge to convention, the brightest area of the painting is the coastal landscape in the distance, a ploy that draws the viewer's eye away from the distorted objects in the foreground. These vibrant tones seem to frame an area of intense shadow that spreads right across the bottom half of the canvas. Here lies a distorted mass resembling a human face, its flesh dull and blue-tinged in a suggestion of dead flesh, intensified by the warm ocher tones that surround it.

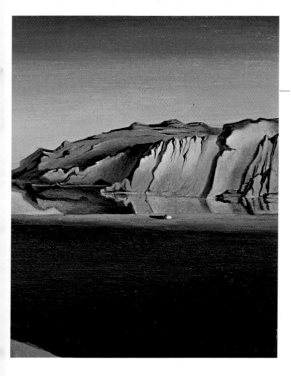

Despite the eeriness with which Dalí lights his scenes, the luminosity with which he paints light is reminiscent of the Dutch school, Jan Vermeer in particular.

Dalí retained the brilliance of his colors by working onto a white ground. Rather than work from dark to light, he underpainted areas of shadow using raw umber, sometimes mixed with black, retaining the white canvas as the base for lighter tones. The painting was built up using thin layers of oil paint, which allow colors to blend, creating a sense of depth. This technique is particularly evident in the golden blue tones of the sky. Dalí always worked methodically, completing the background first, but it is thought that the seascape depicted here had been painted before he conceived the rest of the composition and was then incorporated into it.

White highlights are applied on top of wet paint and deftly blended. The highlights on the sandy cliffs complement the metallic highlights in the foreground of the painting.

Dalí incorporates a great amount of tonal detail, suggesting light falling on the rugged cliffs. By applying thin paint with a fine soft brush, Dalí invokes the luminosity of the sunlight, both on the cliff and reflected in the calm sea below.

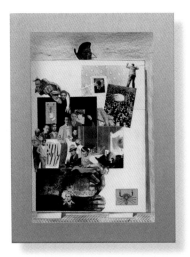

MAX ERNST, 1891–1976

Loplop Introduces Members
of the Surrealist Group
1931, Museum Of Modern Art, New York

BETWEEN 1929 AND 1932 MAX ERNST created a series of mixed-media collages in which he combined photographs with pencil illustrations and elements of frottage (rubbing). These featured a birdlike creature, which their titles revealed to be named "Loplop, Bird Superior." Ernst had a fascination with birds and saw Loplop as an alter ego or animal "familiar" popular in Germanic folklore. As a familiar, Loplop acts or provides commentary on Ernst's behalf. It has also been suggested that Loplop was inspired by Ernst's reading of Sigmund Freud's *Totem and Taboo*, in which he discusses the conflicts of patriarchal authority, constructing the disciplinarian father figure as "totem"; it is thought that Ernst was referring to the "patriarchal authority" of the traditional art establishment.

1922

Stops working in collage. Doesn't take it up again until 1929.

1925

The Surrealist game "Exquisite Corpse" (*see page 51*) is thought to have influenced Loplop's appearance.

1926

In a poem, Paul Éluard describes Ernst's affinity with birds.

As the series progressed, Loplop acquired an enigmatic quality, his facial appearance changing and shifting by various degrees; he occasionally acquires human features or hair; his beak either grows or shrinks; he is depicted as both a detailed illustration and a simple graphic symbol; in 1932 his head is reduced to a simple circle. The titles of the collages begin with the French phrase "*Loplop Présente....*" Accordingly, the composition depicted the avian character holding a rectangular image, presenting it to the audience. By 1931 Loplop's feathered body is entirely concealed by the image he is introducing; just head and hands are visible, as if the creature is wearing a sandwich board, which eventually, as here, becomes intrinsic to Loplop's person.

Loplop Introduces Members of the Surrealist Group was printed in a 1931 edition of a Surrealist Group magazine, *Le Surréalisme au Service de la Révolution*, under the title *Au Rendez-vous des Amis 1931*. The published title is a reference to changes within the group; it refers to a 1922 painting of the same name by Ernst. Painted before the publication of the First Surrealist Manifesto in 1924, that piece was an early indication that the artists saw themselves as a formal group. Central personalities such as André Breton, Pablo Picasso, and Marcel Duchamp were included, as well as those considered their ideological forerunners, Fyodor Dostoevski and Giorgio de Chirico. The 1931 collage includes only seven of the original members, although newer members such as Salvador Dalí and Yves Tanguy are represented. Produced at a time of conflict within the group—which led to the publication of the Second Surrealist Manifesto in 1931—the piece offers Ernst's opinion of the true Surrealists.

13¼ in (33.6 cm)

19¾ in (50 cm)

Fact

Ernst named Loplop after a well-known Parisian street poet called Ferdinand Lop, whom the students of the Latin Quarter referred to by the moniker "Lop Lop."

Cut-and-pasted gelatin silver prints, printed paper, pencil, pencil frottage

1928	1929	1930	1931
Ernst's avian alter ego appears in the painting *Loplop, Bird Superior*.	Loplop appears in Ernst's first collage novel, *La Femme 100 Têtes*.	Early Loplop collages shown at the Galerie Vignon, Paris.	First American exhibition at the Julien Levy Gallery, New York.

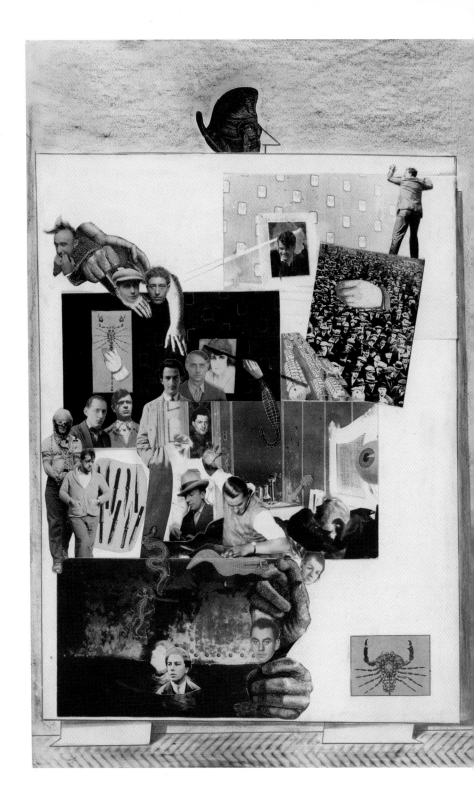

The piece is essentially an image within an image. Loplop's head is visible in profile, emerging above the top edge of a large rectangular composition. This composition is a mixed-media collage, featuring photographs of nineteen members of the Surrealist group. The personalities are arranged asymmetrically, most clustered within a black rectangle that dominates the left of the frame. Central to this area are the figures of Dalí and Ernst. Their location hints that the arrangement is not random but a representative "map" of each member's position within the group. Seven disembodied hands appear in the piece. In most of the series two hands appear, those of Loplop, either holding or gesturing toward the composition's central image. Hands were symbolic of artistic showmanship; the collective Surrealist Group warranted several pairs.

Duchamp appears at the right edge of the collage, his back to the group. Positioned as if scaling a wall, this may be a reference to his waning involvement with the group.

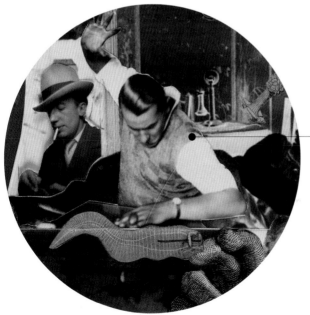

Surrealist leader André Breton is positioned toward the center of the composition in an authoritative stance, one arm raised as if striking a blow.

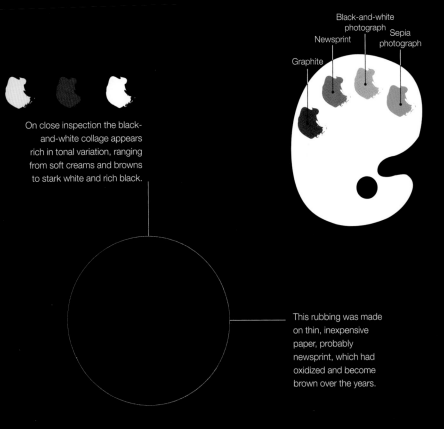

Graphite

Newsprint

Black-and-white photograph

Sepia photograph

On close inspection the black-and-white collage appears rich in tonal variation, ranging from soft creams and browns to stark white and rich black.

This rubbing was made on thin, inexpensive paper, probably newsprint, which had oxidized and become brown over the years.

The color scheme of *Loplop Introduces Members of the Surrealist Group* is largely determined by the artefacts included in the collage. Ernst used black-and-white photographs of individual artists, and sourced further printed material from magazines and newspapers, which he combined with original drawings in graphite. The paper on which the collage is mounted is off-white, but may have yellowed with age. Several composites, either cut from or drawn onto newsprint have aged considerably, assuming brown tones. On close inspection one notices substantial tonal variations in the black-and-white portraits, some of which appear sepia.

The mixed-media Loplop collages make use of a wide variety of found images and artefacts, most of which are black and white. These are frequently combined with pencil illustrations and graphite rubbings, which result in surfaces that are ostensibly monotone.

Ernst obscured Loplop's body with the main area of the composition, a large, rectangular area of collage placed against a gray, tonal background. He defined the outline of this area, as well as Loplop's feet and beak, with precise, ruled pencil lines. This tonal background was achieved by rubbing a textured surface with a soft, graphite stick. This mark-making is interrupted by the embossed edges of the picture plane; this raised area suggests that Ernst defined the parameters of the composition by passing the wet paper through a printing press with a clean metal plate. Ernst assembled the collage itself from a variety of printed and drawn materials, which he cut out by hand using a scalpel. These were fixed to the background using paper glue; the finished collage was again passed through a press to secure the individual components.

A close look reveals the photographs to be cut crudely, with small areas of background visible, particularly around delicate areas such as the hands.

n 1929 Ernst had published the first of graphic novels, *La Femme 100 Têtes*, ructed from nineteenth-century books aglio prints. This work features several taglio prints of hands, which may have come from the same original sources.

These stylized hand-drawn heads reveal that Ernst reused ideas and material in his collages. Two similar portraits appear in a 1932 work, *Loplop présente Paul Éluard*.

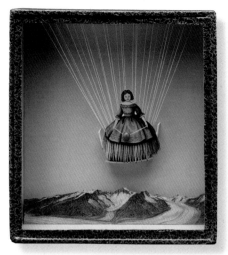

JOSEPH CORNELL, 1903–1972

Tilly Losch

c. 1935, Collection Mr. and Mrs. E. A. Bergman, Chicago

AMERICAN ARTIST JOSEPH CORNELL BECAME ASSOCIATED WITH the Surrealist movement during World War II, when many of its key figures settled in the United States. A self-taught artist, Cornell had earlier been inspired by Max Ernst's Loplop collages, exhibited at the Julien Levy Gallery in New York in 1930. Impressed by what he saw as Ernst's combination of high art and popular images, Cornell amassed a vast collection of found images and began creating collages of his own. These collages came to the attention of Julien Levy, who included them in an exhibition of new Surrealist work in 1931. Throughout the 1930s, Cornell frequently participated in Surrealist exhibitions, although he shared little of their ideology beyond a fondness for irrational or surprising combinations.

1925	**1930**	**1931**
Develops an interest in art; begins visiting New York's galleries.	Experiences Ernst's work at Julien Levy Gallery, New York.	His collages are exhibited alongside European Surrealists.

Although receptive to the modern culture that Ernst and the other Surrealists represented, Cornell's work belies a deep sense of nostalgia. During the early 1930s he began experimenting with three-dimensional objects, creating montages that were eventually refined into distinctive works in boxes, the format for which he is best known. He was adamant that his creations should not contain "junk" but objects that were once precious. An avid collector and archivist, Cornell expressed a desire to create no new images but reinterpret old ones. He later began making short movies, spliced together from old film stock.

Tilly Losch, an early box, is named after an Austrian ballerina and choreographer, who was working as a dancer in New York. It is known that Cornell idolized many performers of the day; *Tilly Losch* is just one of a number of pieces celebrating these B-movie actresses and other minor stars of stage and screen. In this assemblage an old-fashioned cardboard doll becomes a surrogate for Tilly Losch, but in other works he utilized promotional photographs of performers.

Cornell was unlucky in relationships and remained at home throughout his life nursing a sick mother and brother. It is hardly surprising that his enclosed boxes are often interpreted as metaphors either for containment or escape. Small birds, both stuffed and made of paper, occur regularly, a sentimental symbol of the human spirit. In *Tilly Losch* a wooden doll is suspended by the strings of an unseen parachute or hot-air balloon; each contraption being the inverse of the other, it is unclear whether the doll is flying away or plummeting to the ground.

9¼ in (23.5 cm)

10 in (25.4 cm)

Fact

Cornell worked as a textile salesman from the time he left school in 1921 until he lost the job in 1931. Throughout the 1930s he continued to supplement his income with poorly paid jobs.

Mixed media
Depth: 2 in (5.4 cm)

1932	1933	1935	1936
Produces first works in boxes.	Meets Marcel Duchamp; is inspired to produce more ambitious work.	Completes *Tilly Losch*.	Designs the front cover of a book about Surrealism published by Julien Levy.

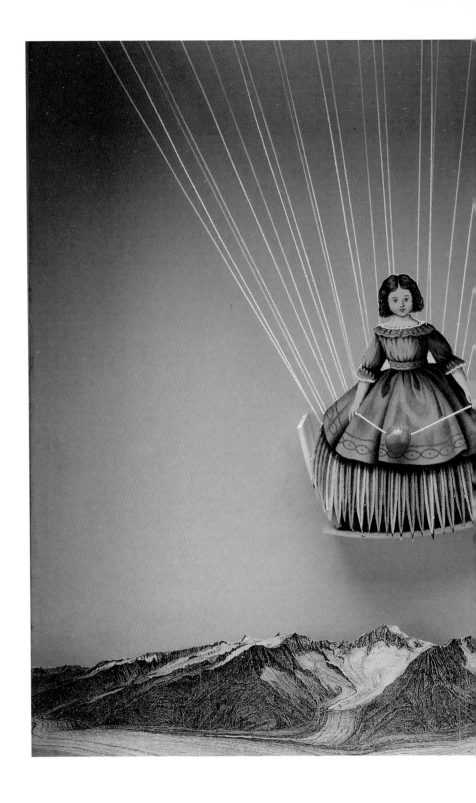

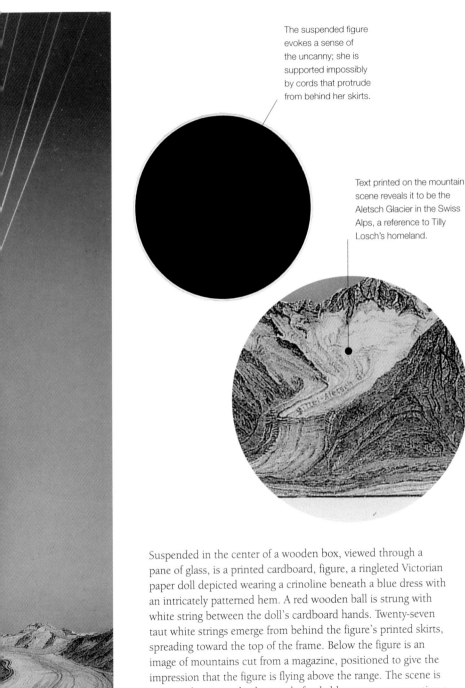

The suspended figure evokes a sense of the uncanny; she is supported impossibly by cords that protrude from behind her skirts.

Text printed on the mountain scene reveals it to be the Aletsch Glacier in the Swiss Alps, a reference to Tilly Losch's homeland.

Suspended in the center of a wooden box, viewed through a pane of glass, is a printed cardboard, figure, a ringleted Victorian paper doll depicted wearing a crinoline beneath a blue dress with an intricately patterned hem. A red wooden ball is strung with white string between the doll's cardboard hands. Twenty-seven taut white strings emerge from behind the figure's printed skirts, spreading toward the top of the frame. Below the figure is an image of mountains cut from a magazine, positioned to give the impression that the figure is flying above the range. The scene is presented against a background of pale blue paper, representing a clear sky, and framed by an old picture frame, its surface daubed with paint to resemble leopard print.

The crisp white strings become a graphic echo of the sweeping paths of ice that flow across the surface of the glacier below.

Emerald green

Cadmium yellow

Burnt umber

Ultramarine

The blue paper background encompasses the back, sides, and bottom of the box, suggesting a clear sky and its reflection in water below.

Cadmium red

Emerald green

The colors of the composition are determined by the printed paper materials from which it is assembled. The box is backed with pale blue construction paper, similar in tone to the highlights on the figure's dress. The rest of the doll's dress is a mid-blue, printed with Prussian blue shadows. From beneath it, underskirts striped in red, yellow, green, and blue are visible. The doll's hair is dark brown and her skin an even peach. She is printed with muted inks, as if faded over time, although the printed black details remain crisp. The image of the Alps is a monotone print, although areas of dense detail appear blue against the azure background.

The found objects used within Cornell's assemblages reveal a wide variety of color schemes. His appreciation of incongruous combinations encompasses color as well as objects. Here, the leopard-skin pattern of the frame seems mismatched with the faded Victoriana within the box.

Cornell painstakingly assembled the contents of the box; here each string has been individually measured and fixed and the platform elevating the paper doll carefully and cleanly constructed. Even the paper doll and the mountain range below have been cut out with great care using a scalpel.

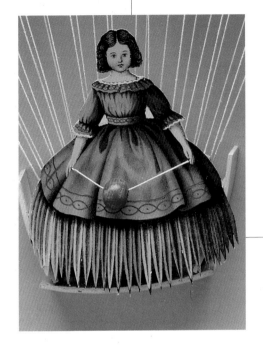

The edges of the doll are crisp, with clean white edges, suggesting that Cornell found the image in its original printed format and cut it out himself.

The doll is printed using an intaglio technique known as gravure printing, which was first developed in the fifteenth century and remained the primary method of commercial printing into the twentieth century.

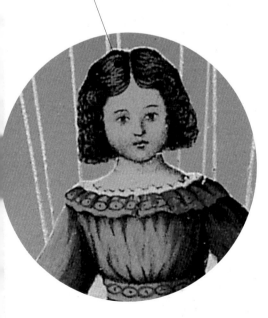

In *Tilly Losch,* Cornell has papered the interior of the box before constructing a platform from thick cardboard onto which the figure is affixed with glue. The platform, which follows the curve of the doll's skirts, enables the figure to "float" in the foreground of the composition, affording a sense of perspective. Both the doll and the mountain scene are two-dimensional illustrations, but Cornell supplements them with a red wooden bead, representing a child's ball. The ball is threaded on a string, which is stretched through two punched holes near the doll's hands. The longer strings intended to afford the doll the illusion of floating, are glued to the back of the cardboard figure, and on the top edge of the box.

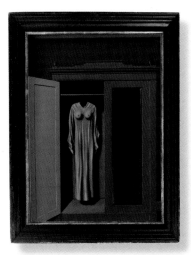

RENÉ MAGRITTE, 1898–1967

In Memoriam Mack Sennett
1936, Musee Comunal, La Louviere, Belgium

IN MEMORIAM MACK SENNETT DATES FROM RENÉ MAGRITTE'S mid-career, a tumultuous period during which he enjoyed an international reputation as one of Surrealism's masters, while at the same time trying to distance himself from the movement that had aided his success. The painting is thought to have been among a number of works exhibited at The Hague in the winter of 1936.

Magritte's earlier paintings employ absurd combinations of objects, characters, and landscapes, resulting in fantastical dreamscapes. In contrast, *In Memoriam Mack Sennett* is set within an unassuming domestic bedroom, adding an echo of reality to the disturbing shape hanging within the brown wooden wardrobe.

1912	1925	1927
Magritte's mother commits suicide by drowning.	Abandons experimental Cubist style and begins experimenting with Realism.	Moves to Paris and meets Breton. Joins the Surrealist group.

Magritte's vision of a woman's nightdress with realistic breasts is thought to relate to memories of his mother's suicide; in 1912 she drowned herself in the River Sambre and was fished out in her nightgown. The lack of decoration on the garment suggests the simplicity of a shroud, adding a funerary tone to the image.

Despite the autobiographical interpretations proffered, Magritte's utilization of the female form is in keeping with Surrealist precedents—the reduction of the female body to its individual elements. Early Surrealist artists were aware of the idealized, distant, often erotic depictions of women popular in the nineteenth century, and pushed the boundaries of this subjective gaze, reimagining their models without limbs, torsos, or even heads. This reduction of the female form was intended to subvert its sexuality, while amplifying the subject's remote status beneath the viewer's gaze.

The title of the painting adds an irreverent perspective to the work. Magritte notoriously claimed that his titles had no meaning, but the inclusion of the name of a well-known celebrity invites some interpretation. Mack Sennett was a prolific producer of comedic films, forced into early retirement during the early 1930s after his Hollywood studio failed to recover from the Great Depression. Magritte's reasons for honoring the filmmaker in the title of the painting are unclear, but it is known that Sennett was, for a time, a cult figure admired by many associated with the Surrealist movement. It is possible that the naked breasts are a coy reference to a series of risqué silent films entitled *Sennett's Bathing Beauties* that were produced during the 1920s, although it is impossible to do much more than speculate upon the cultural or psychobiographical references apparent in any of Magritte's creations.

21¼ in (54 cm)

29 in (73 cm)

Fact

As a child, Magritte's favorite playground was a local cemetery. This early influence can be seen in the funerary implications of his work; in several pieces he uses tombstones as a recurring motif.

Oil on canvas

1929	1930	1936	1937
A holiday with Dalí leaves Magritte critical of the hallucinogenic aesthetic associated with the movement.	Returns to Brussels following a dispute with Breton over the direction of Surrealism.	*In Memoriam Mack Sennett* is completed.	First London exhibition marks Magritte's international reputation.

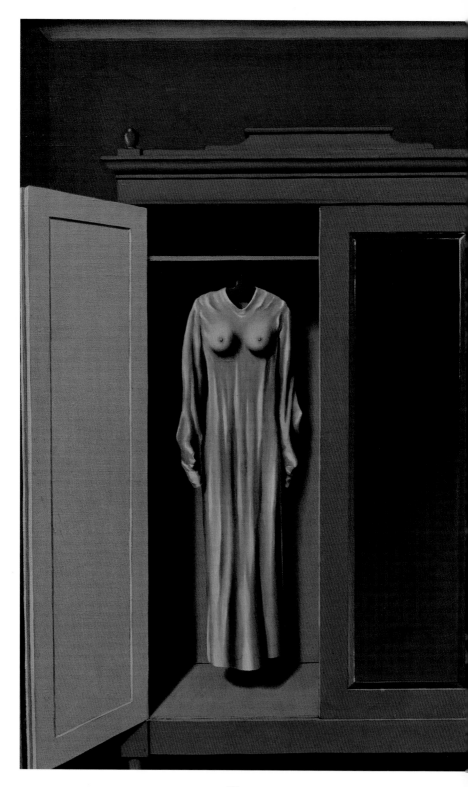

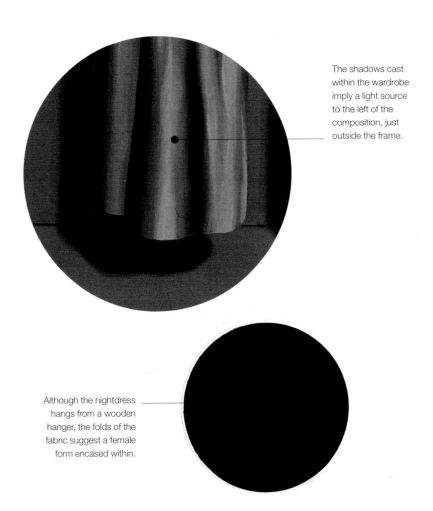

The shadows cast within the wardrobe imply a light source to the left of the composition, just outside the frame.

Although the nightdress hangs from a wooden hanger, the folds of the fabric suggest a female form encased within.

Magritte chooses an unusual composition in which the focal point of the painting is contained within the left-hand side of the frame. The canvas is filled by a large, brown wardrobe, creating a sense of claustrophobia. The open wardrobe door is the major element in the painting that suggests a depth of field, a lone, diagonal structure interrupting the rigid, horizontal and vertical lines of the composition. The edge of the door protrudes beyond the picture plane, inviting the viewer into the space to experience the scene from the perspective of the artist. The door draws the viewer's eyes across the canvas to rest on the mutated nightdress, the focus of the painting, hanging alone within the wardrobe's shadowy interior.

Prussian blue | Burnt sienna | Burnt umber | Yellow ocher

During this period, Magritte painted many interior scenes. The subdued tones of this work are typical, and replicate the color schemes that were popular in ordinary homes of the 1930s. His later work is produced with a fresher palette, often incorporating a signature sky blue.

White highlights and rich shadows suggest the gown is made from tactile silk or satin, which contrasts with the solid furniture.

The pale wood of the open door is reflected in the fleshy tones of the breasts, drawing the viewer's eye.

The overwhelming tone of the painting is one of oppression and austerity, augmented by the shades of brown that dominate most of the frame. In order to create a sense of claustrophobia, Magritte varies his palette very little, placing the ocher wood of the wardrobe against a wall mixed from burnt umber and a floor with tones of burnt sienna. The colors appear deep and heavy, suggesting that the paint was applied to a dark ground. The shadows are created using umber and Prussian blue or ultramarine. The blue tones recede against the warmer tones of the wood, creating a sense of depth, which compensates for the shallow depth of field afforded by the composition.

Magritte was unique in his rendering of natural daylight. The considered brushwork used here creates an evenness which, combined with the painting's muted palette, evokes pale, early morning sunlight, offering an additional dimension to the painting's narrative.

The same technique is used at the edges of the breasts, this time giving the impression that they are growing from the folds of the fabric.

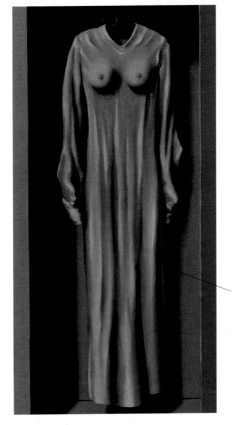

During this period, Magritte's style is almost photorealistic and, although brushstrokes are visible on close inspection, the method is not traditionally "painterly." Magritte applied the paint carefully, using horizontal or vertical strokes depending on the angle of each element; the hanging nightdress is fashioned by downward strokes, suggesting gravity, while on the wardrobe the direction of the wood grain is suggested. The flat, tonal expanses that cover much of the canvas are constructed of short, flat brushstrokes, reminiscent of the work of de Chirico, whom he admired, but also of the advertising imagery he had helped create as a graphic artist. Magritte retained an affinity with advertising, appreciating the implicit interplay between reality, aspiration, and fantasy.

Here Magritte creates depth by working areas of shadow with translucent paint, through which other tones can be seen.

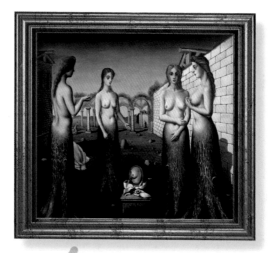

PAUL DELVAUX, 1897–1994

The Break of Day

1937, Peggy Guggenheim Collection, Venice

ALTHOUGH NEVER AN OFFICIAL MEMBER, Paul Delvaux was associated with the Belgian Surrealist movement throughout his career. During the mid-1930s he developed a signature motif in which groupings of erotically disrobed, yet introspective female nudes are displayed within mysterious, brooding landscapes. *The Break of Day*, is an early example of this. In common with the women in his later paintings, these figures are almost a caricature of classical beauty, with large, exaggerated eyes, small mouths, and voluptuous figures. Few men are present in Delvaux's fantasies. Those that do appear are background characters; diminutive, distant figures, secondary to the self-composed, invulnerable women with whom he was obsessed. In *The Break of Day*, for instance, a dark-suited man walks through an avenue of arches, so small and anonymous that he could pass unnoticed by a glancing viewer.

1929

Delvaux first becomes aware of Surrealism. Introduced to Magritte by a mutual friend.

1930

Visits Spitzner museum where a female waxwork known as *The Sleeping Venus* captures his imagination.

1932

Paints his first "Venus"; the prototype of the figures for which he would become known.

Painting imaginative dreamscapes that playfully juxtaposed incongruous objects and figures within equally bizarre settings, it is known that Delvaux was influenced by René Magritte. Both artists understood and made use of the visual power achieved by combining the fantastic with the real, and rendered their paintings with great detail and realistic precision.

Delvaux had an enduring fascination with classical imagery, from the frescos he studied as a youth to classical depictions of Greek and Roman goddesses, evident in the statuesque figures and elongated limbs of the women he conceived.

Delvaux shared his classical interests with Giorgio de Chirico, and was inspired by his paintings. He wrote of de Chirico, *"with him I realized what was possible, the climate that had to be developed, the climate of silent streets with shadows of people who can't be seen."* The older artist's influence is visible here, in the classical columns of the distant avenue, and the vast expanse of sky beneath which the scene unfolds, accentuating the deep perspective of the composition. Like de Chirico, the architectural structures in Delvaux's paintings seem almost insubstantial, too clean and new, as if they were stage flats imported for the scene.

The frailty of Delvaux's landscapes does not detract from the whole, but adds an air of theatricality. The walls that flank the four figures in *The Break of Day* focus the viewer on the scene unfolding center stage, casting his mysterious women as participants in a surreal *tableau vivant*. This dramatic aesthetic is heightened by the picturesque grouping and expressive, yet frozen gestures of his subjects.

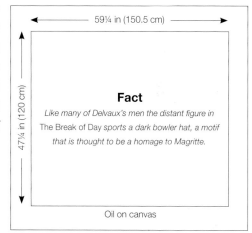

59¼ in (150.5 cm)

47¼ in (120 cm)

Fact

Like many of Delvaux's men the distant figure in The Break of Day sports a dark bowler hat, a motif that is thought to be a homage to Magritte.

Oil on canvas

1933

Destroys more than 100 of his early works during a period of melancholy.

1936

Joint exhibition with Magritte at the Palais des Beaux-Arts, Brussels.

1937

Completes *The Break of Day*.

1938

Participates in "Exposition Internationale du Surréalisme" at Galerie des Beaux-Arts, Paris.

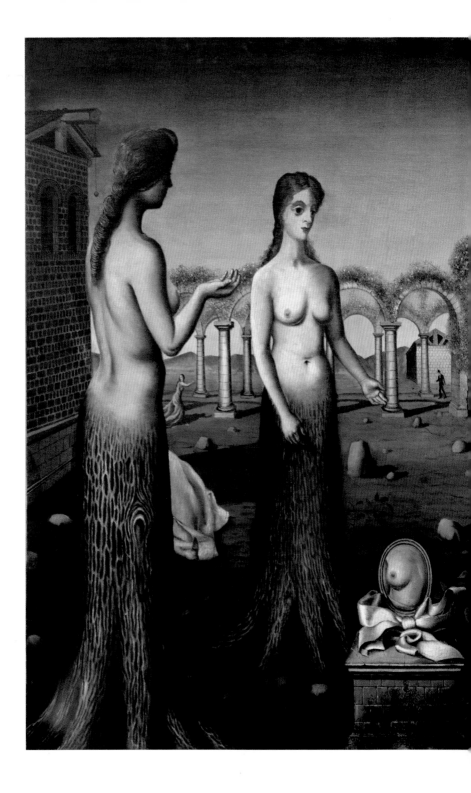

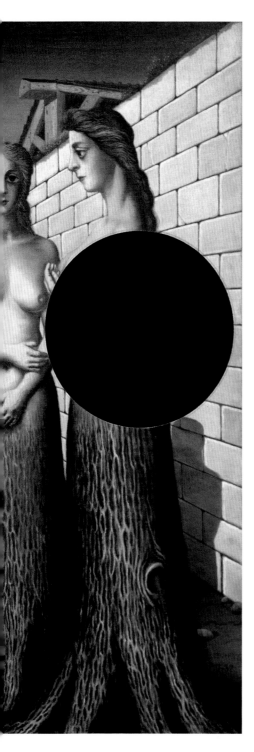

Under a dawn sky stand four female nudes. Below the navel their bodies are transformed into thick tree trunks, the uneven knotted texture a stark contrast with the soft, pink flesh of their torsos. The nudes gather in a semicircle around a small stone plinth, upon which is perched an oval, gilt-framed mirror. Reflected in the mirror is a single breast, positioned as if reflecting a fifth, unseen woman. The composition is set beneath a sunrise of graduating yellow and blue tones, and framed by the walls of two buildings that are agricultural in appearance. In the distance is an avenue of arching columns, clad in foliage, beneath which a single male figure can be viewed. To the left of the arches is a female figure in a pale flowing gown, her arms outstretched as she runs toward the man.

Delvaux's nudes are most frequently depicted in nocturnal scenes, or, as in *The Break of Day*, at dawn. Typically, Delvaux chose a cool palette of white, gray, and blue, evoking moonlight or pale sunlight, which casts lengthy shadows, affording his dreamlike scenarios an ethereal quality.

Around the women's hips soft flesh merges with rough bark. The shadows of both surfaces are created using similar tones, mixed from burnt umber and ultramarine, creating visual consistency.

Yellow tones, introduced toward the top of the tree trunk, link flesh and bark, but also blend with the ocher soil of the ground, underscoring the women's relationship with the earth.

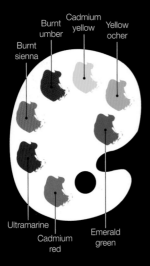

Burnt sienna
Burnt umber
Cadmium yellow
Yellow ocher
Ultramarine
Cadmium red
Emerald green

Delvaux cleverly dissects the painting into three horizontal, tonal sections; the creamy torsos of the figures and plane of the pale stone wall to the right of the composition lead toward white arches set against the pale sky of the horizon. This pale, central panel is framed by a receding strip of dark, night sky at the top of the picture plane, and the heavy brown and green tones of the foreground, including the tree-trunk limbs of the four muses. By dividing the canvas in this way the viewer's gaze is drawn toward the female forms at the center of the picture plane, creating a period of suspended reality before the realization that the women are not wearing long, fluted skirts, but are merged with tree trunks that root them to the ground.

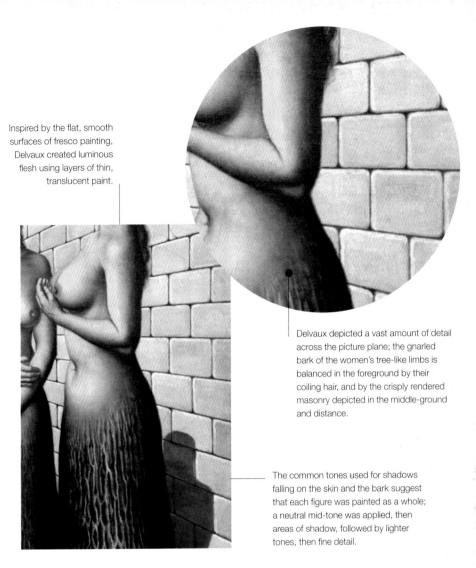

Inspired by the flat, smooth surfaces of fresco painting, Delvaux created luminous flesh using layers of thin, translucent paint.

Delvaux depicted a vast amount of detail across the picture plane; the gnarled bark of the women's tree-like limbs is balanced in the foreground by their coiling hair, and by the crisply rendered masonry depicted in the middle-ground and distance.

The common tones used for shadows falling on the skin and the bark suggest that each figure was painted as a whole; a neutral mid-tone was applied, then areas of shadow, followed by lighter tones, then fine detail.

Delvaux's biomorphic figures and uncanny juxtapositions owe much to the influence of Magritte, whom he greatly admired as a young artist. The meticulous detail in which Delvaux renders his fantastic visions owe similar debt to the Surrealist master; the delicacy with which he blends living flesh with inert object, is reminiscent of Magritte's *In Memoriam Mack Sennett*. Delvaux began *The Break of Day* by preparing the canvas with a graduating tonal wash, leading from the deep blue of the sky to the pale ocher of the middle distance, and the rich, earthy tones of the foreground. Close inspection shows that Delvaux painted each area painstakingly, using thin paint and a soft brush. Each element of the painting is formed from multiple tones, all carefully blended to achieve a three-dimensional effect.

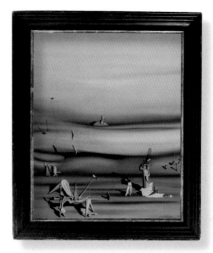

YVES TANGUY, 1900–55

Lingering Day

1937, Musee National d'Art Moderne, Centre Pompidou, Paris

THE PAINTER YVES TANGUY HAS BEEN SOMEWHAT overlooked by history, never quite achieving the notoriety of Salvador Dalí, René Magritte, or Joan Miró despite being, like them, part of Surrealism's inner circle, an early member of the Parisian group, and a close friend of founder André Breton. Tanguy was admired by Breton, who, in 1946, wrote the first monograph on his friend.

Tanguy was not a trained painter. Instead, he spent his early adulthood traveling the world with the French merchant navy. As one of the many Surrealists inspired by Giorgio de Chirico, Tanguy often spoke of seeing a painting by the older man, *The Child's Brain* (1914), in the window of a Parisian gallery in 1922. From that time, Tanguy embarked upon a frenetic period of study, learning to paint first in watercolors and then in oils.

1922

Inspired by de Chirico, Tanguy determines to become a painter.

1925

Joins the Surrealists, having completed just one "surrealist" painting.

1927

First exhibition in Paris.

Some of these early works still survive, and demonstrate a naïve, illustrative, expressionistic style in which primary colors are used liberally. By 1925, the year in which Breton welcomed the novice painter into the newly formed Surrealist group, Tanguy's work had developed a new competence, confidence, and darkness, marking the emergence of the distinctive style for which he would become known; his landscapes of open, desert spaces, where the horizon never quite meets the sky, populated by strange, menacing assemblages, are typically described as "alien." These peculiar dreamscapes are known to have been inspired by the baked African plains that he first experienced as a seaman. Like Dalí, Tanguy was a master at manipulating light to create a sense of unease. The diffused daylight that illuminates his peculiar compositions suggests a cloying, noxious atmosphere, but at second glance they could be seascapes as much as landscapes.

Lingering Day dates from Tanguy's middle period. Like many artists of the 1930s, he was aware of the increasing probability of war. Titled *Jour de lenteur* in Tanguy's native tongue, this also translates as "Day of Slowness," a title that evokes a sense of ennui, even hopelessness, exacerbated by the stillness of the composition. The assemblages that populate the picture plane are troublingly passive, as if unexpectedly halted in their tracks. These forms, structured from almost recognizable composites, owe much to the sculptures and assemblages of Marcel Duchamp, and suggest a similar fascination with mechanics. The threat of war, combined with predictions in the press of a new style of war reliant on technology, add an apocalyptic tone to the robotic structures that inhabit Tanguy's picture planes.

28¾ in (73 cm)

36¼ in (92 cm)

Fact

On leaving the merchant navy in 1918, Tanguy tried to avoid military service, feigning mental illness and epilepsy. He failed to avoid the draft in 1920, however, and he served with the French Army in Tunisia until 1922.

Oil on canvas

1930	1937	1938	1939
Returns to Africa, is again inspired by the landscape and rock formations.	Completes *Lingering Day* in Paris.	Attains support of American art collector Peggy Guggenheim and financial success.	Meets American painter Kay Sage in France and moves to United States.

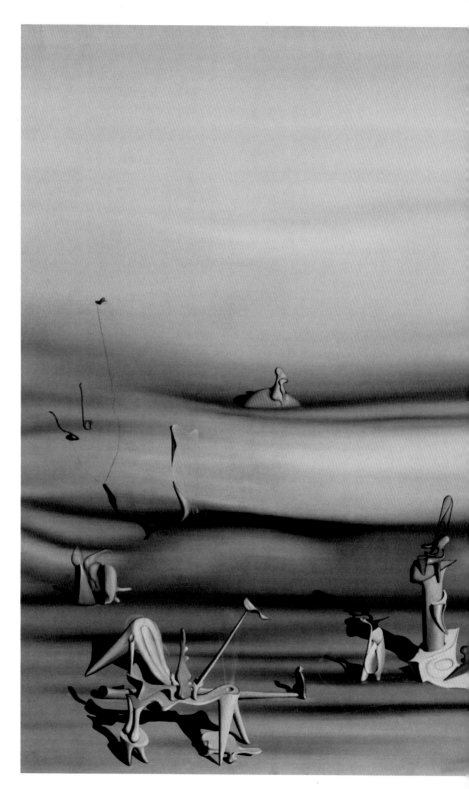

Like most of Tanguy's *oeuvre*, *Lingering Day* portrays an ambiguous setting reminiscent of Dalí's beaches and deserts, while at the same time hinting at aquatic or lunar origins. There is no discernible horizon, the distance suggesting rolling dunes as much as foggy skies. This lack of definition removes the scene from reality, thus creating a brooding sense of foreboding. Arranged in six distinct groupings, strange objects occupy the foreground and middle ground, exuding a strange biomorphic familiarity; in the foreground struts a small, enigmatic, animal-like form. Under a sustained gaze the creature becomes an armored horse, or a small dog, symbolic of the Parisian bourgeoisie. Carefully positioned, these objects lead the eye around the painting, inviting viewers to devise their own symbolism or narrative.

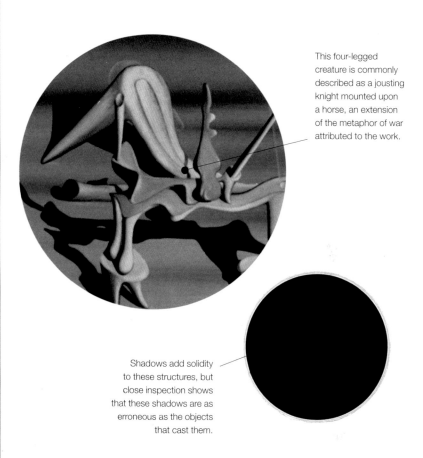

This four-legged creature is commonly described as a jousting knight mounted upon a horse, an extension of the metaphor of war attributed to the work.

Shadows add solidity to these structures, but close inspection shows that these shadows are as erroneous as the objects that cast them.

Dominated by tones of cream, beige, and gray, *Lingering Day* achieves a sense of the somber without the heavy gloom apparent in earlier works. The background is composed predominantly of white, yellow ocher, burnt umber, and ultramarine. The pale top half of the picture graduates downward toward an area of contrasting, cool tones in the bottom third. These natural tones are echoed by Tanguy's assembled forms in a manner suggestive of metallic surfaces. Here they are offset with incongruous synthetic shades: olive green, magenta, vermilion, and cadmium yellow. In the background, shadows cast by undulating sandbanks are mixed from burnt umber and aquamarine. In contrast, the unearthly shadows cast by the landscape's inhabitants are sharply superimposed in black.

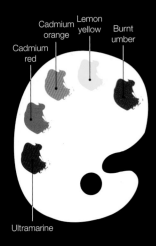

Cadmium orange

Lemon yellow

Burnt umber

Cadmium red

Ultramarine

Subdued purple shadows create a sense of depth and texture within the empty expanses of undulating desert and lead the eye beyond the picture plane.

A warm yellow hue draws the eye toward this area of relative gloom, thus ensuring these angular gray forms are not overlooked.

Tanguy's predilection for subdued, brooding tones of gray is thought to have been influenced by the Brittany coast where he grew up. The 1920s saw large swathes of monotone paint dominate his work, but by 1931 he had introduced more color, as during his formative expressionist period.

Tanguy adapted the Surrealist practice of automatism to create his peculiar biomorphic beings, not by interpreting abstract gestures as other members of the group did, but by allowing the hand to create familiar shapes upon the canvas. He favored working straight onto the canvas in paint, without under drawings or preliminary sketches, seeing the very process of painting as a surrealist adventure. He always began by painting the background, which he achieved by blending fluid color with a large, soft brush. The geography of the background would inform the finished composition. Tanguy added his abstract creations only when the base was dry. They were modeled in thin paint to achieve a smooth, flat surface with only occasional areas of impasto.

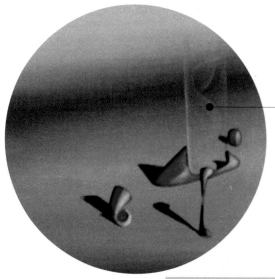

Mysterious, transparent forms appear across the picture plane. Tanguy added these last, using a fine brush and diluted white paint.

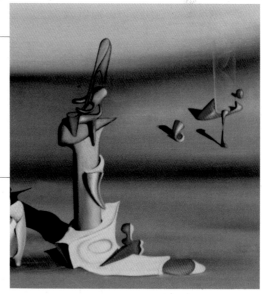

Tanguy was an admirer of Dalí, and the meticulously realized canvases and the paranormally lit expanses in which his hallucinatory scenes are set show the influence of Surrealism's *enfant terrible*.

Tanguy outlined his assemblages finely in black paint. While ensuring visual clarity, these outlines provide a visual barrier between the objects and the landscape.

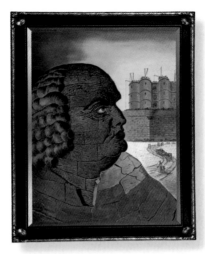

Imaginary Portrait of the Marquis de Sade
1938, Private Collection

AMERICAN ARTIST MAN RAY IS BEST KNOWN as an innovative photographer who revolutionized art photography with his experimental darkroom techniques. His signature technique was solarization, by which he exposed a developing image to light, resulting in areas that appeared in negative. Man Ray was embraced by both the avant-garde and mainstream culture, and he created some of the most iconic images of the twentieth century. Less well known are Man Ray's paintings. He began his professional life as a painter and bought his first camera in 1915 as a tool for documenting his work. The commercial and critical acclaim he enjoyed as a photographer meant that he rarely painted following his arrival in Paris in 1921. Completed in 1938, *Imaginary Portrait of the Marquis de Sade* is an early example of his return to the medium.

1913	1920	1921
In New York meets Duchamp, who later introduces him to Dada artists in the city.	Founds La Société Anonyme with Duchamp in New York.	Moves from New York to Paris, where he joins the Dada circle.

Repressed throughout the nineteenth century, the writings of the notorious Marquis de Sade found a new readership among the Parisian avant-garde in the early decades of the twentieth century. He quickly became a cult figure for the Surrealists, who admired his independence and ability to push the boundaries of taboo. Armed with a Freudian understanding of sexuality and the subconscious, and a predilection for sadomasochism, de Sade wrote prose containing explicit descriptions of shocking sexual exploits, which became a source of fascination for Man Ray, inspiring him to explore the boundaries of fantasy and eroticism.

Within the Surrealist *oeuvre* the female body was already accepted as emblematic of the unconscious world they sought to understand. Motivated by de Sade's fantasies, Man Ray endeavored to create a Surrealist vision of Woman in his photographs, often fetishizing individual body parts and using extreme light and shadow to alter the form, investing his model's bodies with a distorted, dreamlike quality.

Imaginary Portrait of the Marquis de Sade is clear acknowledgment of his debt to the notorious pornographer. No authenticated portraits of de Sade exist, so Man Ray has invented his appearance freely; the results are often compared to the aged André Breton. Strangely, considering Man Ray's fascination, this fantastical portrait is remarkably impassive and devoid of the erotic, sadomasochistic references one might expect. Only de Sade's full red lips hint at sensuality, while the rest of his person is scored as if he is constructed from slabs of stone, echoing the stone facade of the Bastille where he was imprisoned for several years, recognizable to the right of the picture plane.

19¾ in (50 cm)

23½ in (60 cm)

Fact

Man Ray is the pseudonym of Emmanuel Radnitzky. The son of Russian immigrants to the United States, the family shortened their surname to Ray in 1911. The following year Emmanuel adopted the contraction "Man."

Oil on canvas

1925	1937	1938	1940
As Dada fades, he is welcomed by the Surrealist Group.	Resolves to "devote as much time as possible to painting."	Completes *Imaginary Portrait of the Marquis de Sade*.	Returns to the United States following Nazi occupation of France.

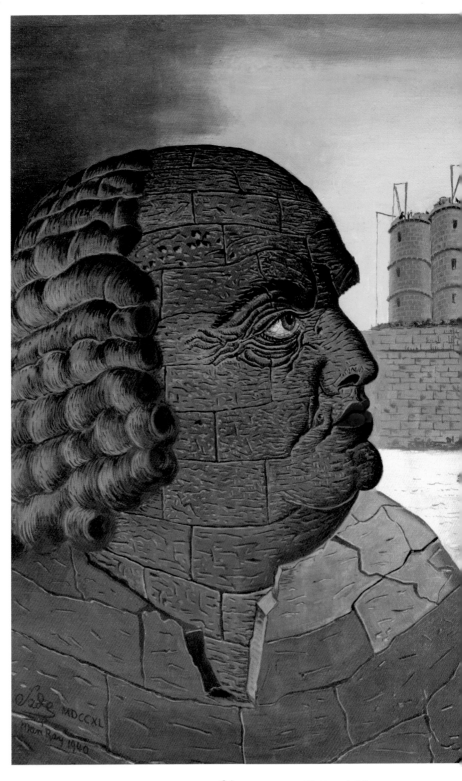

Man Ray depicts de Sade in profile. Over his shoulder a road winds toward the Bastille (now long demolished), where de Sade spent five years of incarceration. The storming and subsequent demolition of the fortress in 1789 is apparently referred to, as wooden cranes lower rocks to the ground. Local folklore alleges that de Sade incited the events of that summer by shouting from his window that the Bastille's prisoners were being murdered, an allegation that led to rioting; de Sade was transferred to a nearby insane asylum at Charenton just a few days before the Bastille was attacked. Man Ray paints de Sade not as flesh and blood but from the same dense stone of the Bastille itself, his face chipped and cracked as if ravaged by revolution. Presented as a statue, only his bloodshot eyes and red lips reveal the face as human.

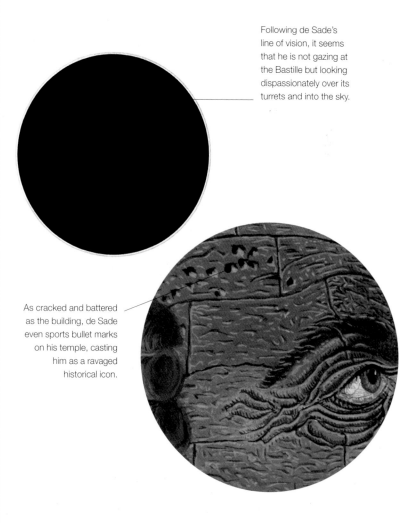

Following de Sade's line of vision, it seems that he is not gazing at the Bastille but looking dispassionately over its turrets and into the sky.

As cracked and battered as the building, de Sade even sports bullet marks on his temple, casting him as a ravaged historical icon.

An overview of Man Ray's *oeuvre* demonstrates influences as diverse as the Dutch Masters and the German Expressionists. In his early works he favored a vivid blue palette, but during the 1930s he painted mainly in rich, earthy tones.

The bright blue of de Sade's eye contrasts with the bloodied whites, evoking the French Tricolor flag, while drawing the viewer's eye to the center of the composition.

The red of the eye is echoed in de Sade's lips, as well as in the carriage wheel and fortress wall of the background, drawing the viewer's eye around the picture plane.

Venetian red

Raw umber

Yellow ocher

Burnt sienna

Chromium green

Naples yellow

Ultramarine

Most of the composition comprises natural tones of gray and brown, the distant Bastille constructed in a cool gray mixed from raw umber, white, and blue. The cool shades recede, emphasizing the distance of the Bastille. The Marquis is painted in slightly warmer tones—raw umber, burnt sienna, and yellow ocher —although details of his pitted skin are highlighted in the same gray as the fortress. The composition unfolds beneath a poisonous-looking sky of chromium green and Naples yellow, which brightens behind the Bastille as if the sun is setting. The unnatural green sky creates a sense of unease but contrasts with the naturalistic stone tones and heightens the visibility of de Sade's complementary red lips and bloodshot eyes.

Close inspection reveals that Man Ray painted the sky last; the yellow paint overlaps de Sade's profile and the fortress walls.

The broken lines of the wooden cranes in the distance draw the area out of focus, creating a sense of distance.

A less accomplished painter than many of his contemporaries, Man Ray's awkward perspective and often unsophisticated handling of paint evoke a youthful naivety, often at odds with the ideological allusions in his work.

As a young man, Man Ray had seen works by artists such as Vincent van Gogh, Paul Cézanne, and Paul Gauguin exhibited in New York. Post-Impressionist techniques were common in his early work, and are visible here, particularly in the background, where figures and other fine details are executed with a few deft brushstrokes. The portrait of de Sade is rendered in great detail. Man Ray works from dark to light, blocking in each stone slab before adding textural details with a fine brush; the face is covered with hundreds of chips and cracks, each defined with an area of shadow and highlight.

FEDERICO CASTELLON, 1914–71

The Dark Figure
1938, Whitney Museum of American Art, New York

THE SPANISH-BORN PAINTER FEDERICO CASTELLON is well known in the United States due to his short association with the Surrealists working in New York throughout the 1930s and 1940s; during this period he frequently exhibited in Surrealist retrospectives, alongside fellow countrymen Salvador Dalí and Pablo Picasso. *The Dark Figure* is one of Castellon's best-known works and an early example of the style for which he became known as a mature artist.

Castellon's professional career began in earnest in 1934, when he received a scholarship from the Spanish government, allowing him to return to Europe for a year. During this period he traveled in Spain and France, immersing himself in the public museums and art galleries. It was during this trip that he first became aware of the Parisian Surrealists, although his French was so poor that

1921

The Castellon family moves from Spain to New York.

1928

Begins studying Old Master paintings in his spare time.

1933

Leaves high school and dedicates himself to painting.

he had little to do with the group, meeting members, including Dalí, only in passing. Interviewed during the year of his death, Castellon maintained that *"I was called a Surrealist without ever thinking that I was."*

Despite never being an official member of the Surrealist Group, Castellon was touched by the symbolism and high emotion often evident in their works. While living in Paris he completed several stylized paintings inspired by the Surrealist fascination with automatic drawing and the unconscious. Although less than accomplished, these early experiments paved the way for his growing fascination with fantasy and the irrational, which he later refined into highly charged dreamscapes, such as *The Dark Figure*. Comparison with the nightmarish desert scenes of Dalí is inevitable—and intentional—for Castellon felt that he and the older artist shared a taste for "poetic mysticism," as well as a sense of melodrama associated with the Spanish Masters.

Dalí aside, Castellon drew most of his inspiration not from the world of painting, but the world of literature. A love of melodrama was to lead him to the works of his greatest literary influence, the American Romantic short-story writer Edgar Allan Poe. Although none of his paintings is based on the writer's macabre narratives, Castellon acknowledged that he was impressed by Poe's characterizations of solitary and haunted individuals. The "obscure figure" from which this painting takes its name, with her nineteenth-century dress and intensely concealed identity, seems a personification of Poe's Gothic concerns with love and death. She is comparable, perhaps, to the "ill angels" or "shrouded forms" that appear in Poe's well-known poem "Dream-land."

26 in (66.4 cm)

17 in (43 cm)

Fact

Castellon received no formal art training, but taught himself to paint by copying Old Master paintings from books. He is said to have mastered Realist techniques by the age of sixteen.

Oil on canvas

1934	1935	1938	1941
First solo exhibition in New York.	Visits Surrealist exhibition at the Cité Universitaire in Paris.	*The Dark Figure* is shown at the Whitney Museum, New York.	Takes up etching, begins to re-establish himself as printmaker.

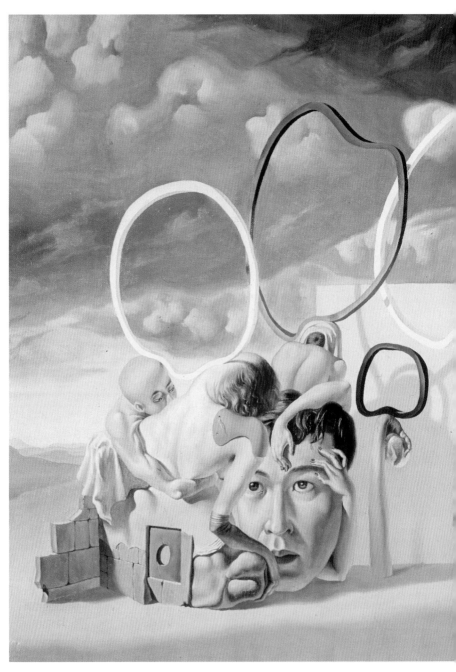

Set in a sprawling desert beneath a tumultuous, stormy sky, the painting depicts an uneasy fantasy scene. The dominant form is a female figure to the right of the picture. Shrouded in a deep burgundy gown, she is obscured by a makeshift hood, tied tightly at the neck; only her clenched hands are visible, their knots and tendons betraying both tension and old age.

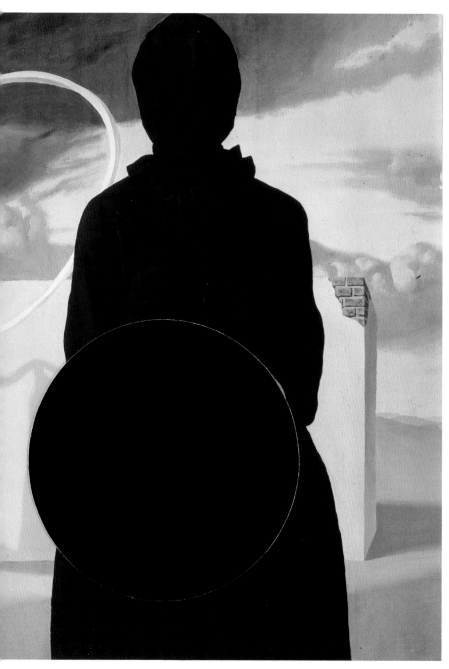

Behind this upright figure a deformed fantasy world unfolds; a large male head in the middle distance stares straight ahead as it is swamped by partial figures and disembodied limbs. Four hoops, misshapen and buckled, are held aloft by the tussling mass, casting pale shadows against a crumbling white wall from which long, elegant, female arms sprout.

In *The Dark Figure* Castellon abandons his usual palette of strong, earthy ocher, umber, and sienna, used straight from the tube. His more sophisticated use of color in this work marks the Realist style in which he had begun working.

Castellon has chosen a pale palette of diluted tones. In the background, pastel tones dominate; rolling gray clouds give way to soft blue sky to the right. The desert sands that stretch into the distance are equally pale, achieved by mixing the barest hints of ocher and umber with white. The clouds cast pale shadows across the background scene, affording a ghostly quality to the squirming group. This chaos of human flesh shares its palette with the background, emphasizing that it belongs to the scene. In contrast, the richness and solidity of the woman's burgundy gown marks her as "other."

The male's dark hair is the second darkest element of the composition, making this mysterious, disembodied head the second focal point.

Cadmium yellow

Raw umber

Burnt umber

Yellow ocher

By introducing a rich red, similar to the figure's gown, into the male lips, Castellon subtly draws the viewer to the background scene.

Ultramarine

Cadmium red

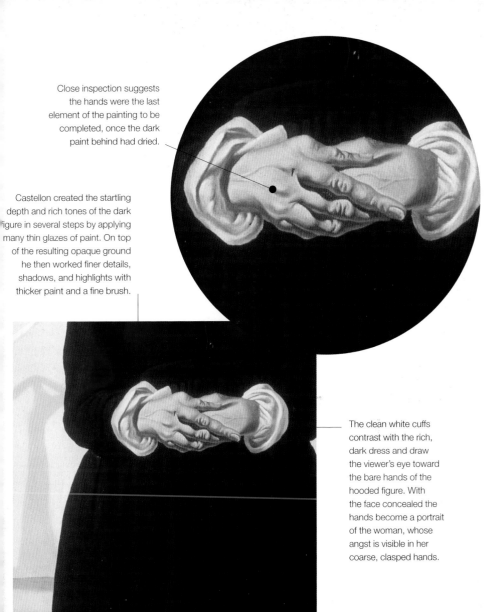

Close inspection suggests the hands were the last element of the painting to be completed, once the dark paint behind had dried.

Castellon created the startling depth and rich tones of the dark figure in several steps by applying many thin glazes of paint. On top of the resulting opaque ground he then worked finer details, shadows, and highlights with thicker paint and a fine brush.

The clean white cuffs contrast with the rich, dark dress and draw the viewer's eye toward the bare hands of the hooded figure. With the face concealed the hands become a portrait of the woman, whose angst is visible in her coarse, clasped hands.

During the late 1930s it is possible to discern a new maturity in Castellon's technique. *The Dark Figure* is an early example of a definite move away from the naïve abstraction the painter favored early in his career. Castellon's admiration for Salvador Dalí is thought to be behind his new, Realist technique. Like Dalí he was a fine draughtsman, capable of mimicking many styles. The older artist's influence is unambiguous in paintings of this period; Castellon worked onto a pale ground, building up glazes of color with a small, flat brush in order to achieve a flat surface on his canvases, before applying details with a fine, soft brush.

SALVADOR DALÍ, 1904–89

Shirley Temple
1939, Museum Boijmans van Beuningen, Rotterdam

ALTHOUGH BEST KNOWN FOR HIS WORK IN OILS, Dalí was a prolific and experimental creator. His work, encompassing photography, film, collage, printmaking, sculpture, and installation often revealed a deep understanding of popular culture and its iconography. Dalí created this piece after seeing the child actress Shirley Temple at the height of her career in the 1939 movie *The Little Princess*. It was her first color movie, an early example of the medium, which the artist marks with a sly trompe d'oeil label proclaiming "Shirley Temple, at last in Technicolor."

The full title of this piece is *Shirley Temple, the Youngest, Most Sacred Monster of the Cinema in Her Time*. This mixed-media collage superimposes a newspaper photograph of Shirley Temple onto the body of a stylized, sexualized sphinx.

1934	1936	1938
Marries Gala Éluard, the former wife of Paul Éluard.	Lectures at International Surrealist Exhibition, in London.	Travels to London to visit Sigmund Freud.

Through the nineteenth and twentieth centuries the sphinx was associated with the dangerous sexual woman, *la femme fatale*. The combination of Hollywood's vision of childhood with a sexual motif is generally accepted to be Dalí's critique of a seemingly modern concern, the sexualization of child actors and actresses by Hollywood. Two years earlier the writer Graham Greene had publicly condemned the eroticization of Temple by movie-makers. It was a high-profile case of which Dalí may well have been aware.

Whether the piece was intended as condemnation or mere observation is unclear. For the Surrealists, childhood was symbolic; in the First Surrealist Manifesto of 1924 André Breton claimed, *"The spirit which takes the plunge into Surrealism exultantly relives the best of its childhood."* The female child, whom they idealized as the *femme-enfant* ("woman-child"), was a popular motif used to represent fantasy, imagination, and the marvelous, offering the opportunity to return to a state of childlike wonderment at the world.

The human bones in the foreground, clearly the creature's last meal, take on phallic forms, denoting Shirley as a "man-eater." In the background are several figures, most notably a lone girl with a skipping rope, a motif used repeatedly by Dalí to represent the liberty of youth. A large bat perches on the actress's head. The relevance of this motif has entered common lore: as a child Dalí discovered an injured bat. Returning later to give it some food, he found it had been devoured by ants. Dalí, consumed with pity, is said to have eaten the remains of the bat's head. Whether or not the story's ending is true, destructive ants feature as a symbol of decay in many of his best-known works.

39½ in (100 cm)

29½ in (75 cm)

Fact

In 1946, Dalí and Walt Disney began working on a cartoon together. Destino was left unfinished until, in 2004, animators retrieved the original stills, drawn by Dalí, and made the film.

Gouaches, pastel, and collage on paper

1939

Completes mixed-media piece, *Shirley Temple*.

1940

Flees with Gala to the United States, fearing German occupation.

1941

First retrospective at Museum of Modern Art, New York.

1942

Publishes auto-biography, *The Secret Life of Salvador Dalí*.

Dominating the foreground a hybrid of Shirley Temple and sphinx surveys the stripped human bones of its last meal. The sphinx is a caricature of female sexuality, featuring long, curved talons and pubescent breasts. In contrast to this implication of aggression, Temple's face, cut from a newspaper, remains impassive, creating a dichotomous sensibility of both ignorance and indifference.

Dalí's paintings, the scene unfolds amid sand, in this case a sprawling
t cliffs and townscape suggestive of his Catalan home. In the middle
ked ship, its skeleton echoing the curved bones in the foreground.
ie waterline with several figures, including a girl with a skipping rope,
adows suggesting dusk.

Dalí uses a very limited palette in order to intensify the devilish red body of the sphinx. The darkest elements are determined by the newsprint black of Temple's portrait, which dominates the right of the picture plane; Dalí balances this black in the composition with silhouetted black cliffs to the left. Similarly, the undulating red clouds of the sky serve to balance the dominant red feline form. These areas of black and red, in combination with the bleached white bones, lend the work a stark graphic effect, which is softened only slightly by the addition of more delicate tones; the muted gray paper on which Dalí works has dictated the pastel tones that enliven the background, including eerie reflections of a sunset upon the sand.

A lone girl skips
sunny yellow hal
her as a childish
in contrast to the
eroticism of Shir

For Dalí the primary colors, red, yellow, and blue, from which any subsidiary color can be mixed, are symbolic of purity.

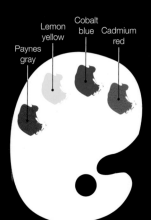

Paynes gray

Lemon yellow

Cobalt blue Cadmium red

Dalí embraced a strong, vibra palette throughout his career. N more famous works, the gray ba and pale tones used in this wo insipid, a little dull even; his cha expanses of ocher and blue conspicuously absent.

Dalí gently smudged the pastels, resulting in an indefinite, distant horizon line in which sea and sand become indistinct.

Shirley Temple is executed in chalk pastel with some washes of watercolor—media that Dalí usually reserved for sketches and preparatory drawings. He blended the colors in a traditional manner, using a fingertip and soft cloth. Temple's head is the only element of collage, the remainder of the composition being hand drawn. For a skilful draughtsman such as Dalí, the style is remarkably naïve, perhaps intended to mimic the style of a young child; the bat perched upon the actress's head is particularly reminiscent of a child's cartoon of a Halloween motif. Despite the childish aesthetic, elements of the drawing, particularly the undulating black shadows that fall across the sphinx's taut body, belie a high degree of competence and control.

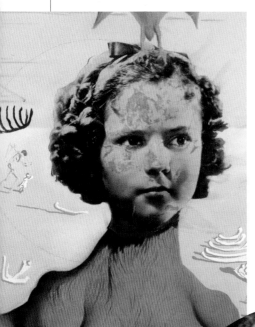

Dalí achieved the fine details, such as the spindly human bones and elongated afternoon shadows, by working with the sharp edge of the chalk pastel. He barely smudged these details in order to retain their definition.

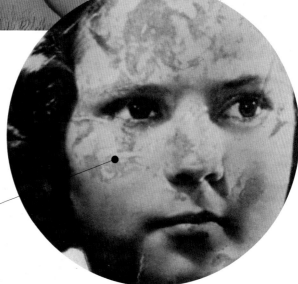

Shirley Temple's head is affixed to the background using ordinary paper glue. The newsprint itself has browned over time.

Birthday
1942, Philadelphia Museum of Art, Philadelphia

ONE OF THE MOST CELEBRATED WOMEN of the Surrealist movement, Dorothea Tanning's reputation was long overshadowed by that of her husband, Max Ernst, whom she married in 1946. Painted at the onset of a long and colorful career, *Birthday* remains Tanning's best-known work.

Tanning studied fine art at the Art Institute of Chicago during the early 1930s. In 1935, in the midst of the Great Depression, she took a bus to New York with just twenty-five dollars in her purse. Supporting herself by working as an illustrator, Tanning continued to paint in her spare time, and frequently visited the city's museums and galleries for inspiration. In 1936 she visited the ground-breaking exhibition, "Fantastic Art: Dada and Surrealism" at the Museum of Modern Art, New York. The exhibition was to have a profound

1936	1939	1941
Sees Surrealist exhibition "Fantastic Art," at Museum of Modern Art, New York.	Interest in Surrealism leads to a summer visit to Paris.	Tanning's future husband, Max Ernst flees to New York following arrest in France as "hostile alien."

impact on her artistic approach. She later recalled: *"I was impressed by its daring in addressing the tangles of the subconscious—trawling the psyche to find its secrets, to glorify its deviance. I felt the urge to jump into the same lake—where, by the way, I had already waded before I met any of them."*

In the late 1930s Tanning acquired a studio in New York's bohemian Greenwich Village. It was here, in 1942, that she met Ernst, who was scouting new artists for the art collector Peggy Guggenheim, whom he had married earlier the same year. The recently completed *Birthday* was among the works in Tanning's studio when Ernst visited her in 1942. The self-portrait is often described as marking the artist's thirty-second birthday, although it is now generally accepted that the work was completed before this anniversary, and that the title was ascribed by Ernst himself. Within a week of meeting the couple had become lovers.

In this self-portrait Tanning wears peculiar and fanciful clothes, the perfect complement to the implausible winged creature that shares the space; a long, bunched skirt with a train of gnarled tree roots, and a rich, satin jacket with large, puffed sleeves reminiscent of another age. Later, speaking about life as a struggling artist in the Village, Tanning revealed: *"A few of us took to wearing old clothes, but they had to be really old, from another time, way back. One of these appears in my painting* Birthday. *It was from some old Shakespearean costume."* Such theatrical castoffs seems fitting attire for an artist whose *oeuvre* traverses the uneasy line between fact and fiction, repeatedly excavating the psychological dramas below the surface of her daily reality.

25½ in (64.8 cm)

40 in (102.2 cm)

Fact

Between 1946 and 1961 Tanning designed sets and costumes for ballet and theater productions in Europe and the United States. She also appeared in two experimental films by director Hans Richter.

Oil on canvas

1942	1942	1944	1946
Meets Ernst; is introduced to other members of the Surrealists.	Completes *Birthday*.	First solo exhibition at Julien Levy Gallery, New York.	Marries Ernst in joint ceremony with Man Ray and Juliet Browner.

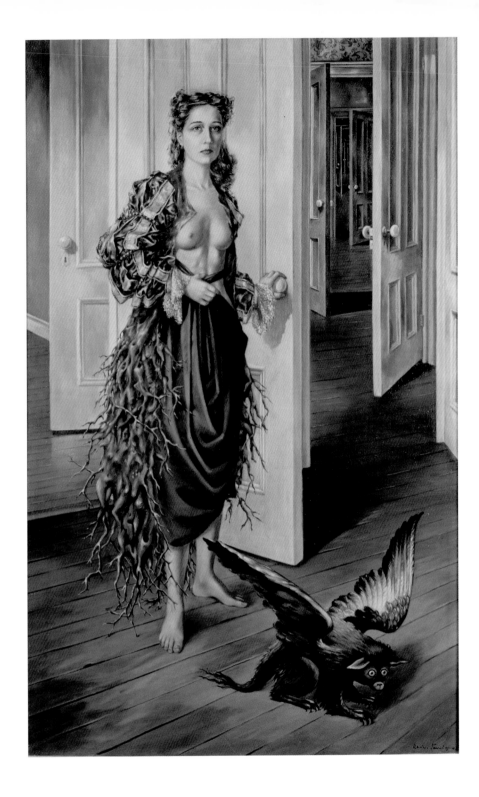

Like much of Tanning's work of this period, the meticulously detailed *Birthday* focuses on the uneasy fantasy life of women. Placing herself to the left of the picture before a mirrored wall, Tanning looks impassively beyond the picture plane to meet the viewer's gaze. Her own, unflinching gaze, coupled with her bared breasts, suggest at once confrontation and impassivity. At her feet crouches an extraordinary bird-winged beast, often described as a lemur. Such fantastic creatures would become a recurring motif in Tanning's later paintings.

To complement the combination of verisimilitude and fantasy that her exotic appearance and extraordinary animal companion create within a domestic interior, Tanning subtly sets the confines of the composition off-kilter; an awkwardly tilted floor, and numerous doorways behind her, allude to the anxieties experienced in dreams.

Tanning's self-portrait, positioned to the left of the foreground, is the composition's focal point. This detailed area is balanced by the view of multiple open doors that dominate the right of the picture plane.

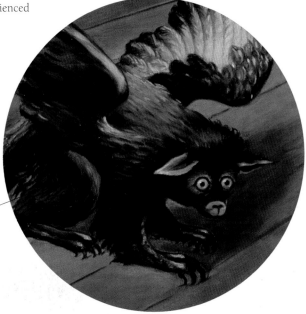

The regular pattern of feathers on the hybrid creature's wings echo, in turn, the regular parallel lines of the paneled doors behind it.

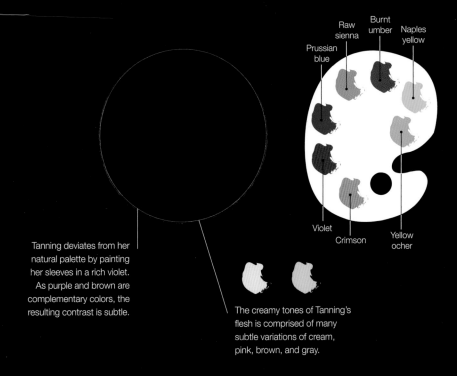

Prussian
blue

Raw
sienna

Burnt
umber

Naples
yellow

Violet

Crimson

Yellow
ocher

Tanning deviates from her natural palette by painting her sleeves in a rich violet. As purple and brown are complementary colors, the resulting contrast is subtle.

The creamy tones of Tanning's flesh is comprised of many subtle variations of cream, pink, brown, and gray.

As the 1940s progressed, Tanning's paintings became increasingly dark, with her dreamscapes focusing on unsettling representations of childhood and adolescence. These thematic changes are paralleled in the deep colors with which she furnished her compositions, frequently using deep blues, greens, and shadowy black.

For *Birthday* Tanning chooses a subdued palette of warm cream and coffee tones, offset only by the rich, regal violet trim of her satin sleeves. By working with a restricted palette, Tanning achieves visual cohesion. The creamy flesh of the artist's exposed torso to the left of the composition is echoed by the many painted doors that dominate the right of the picture plane. Similarly, the dark chocolate color of her fantastic companion at the bottom of the composition is balanced by the artist's long, ruched skirt. Despite the overall consistency of Tanning's chosen palette, the neutral domestic interior within which the scene is set provides a visual contrast to the exotic depiction of Tanning and her extraordinary animal companion.

During this period Tanning worked in a Realist style, carefully rendering areas of light and shadow with small, even brushstrokes. *Birthday* exhibits an almost luminous quality, achieved by applying thin layers of oil paint; wet paint is usually applied to dry paint in considered stages. To achieve luminosity, Tanning worked onto a pale ground, building up tonal layers with a small, flat brush before applying details with a fine, soft brush. Despite sharing with the Surrealists a fascination with fantasy and the subconscious, it is notable that Tanning's style had matured by the time she became associated with the group; her style owes more to eighteenth-century Romanticism, but it also exhibits the picturesque conceits of pictorialist photography.

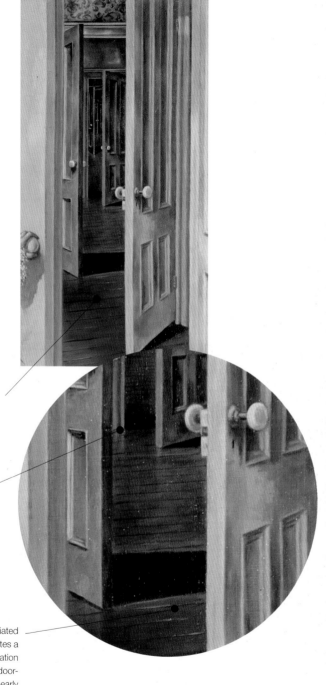

Carefully constructed perspective creates a sense of depth. Tanning augments this technique by using smaller, finer brushstrokes to paint distant areas.

Tanning created rich areas of distant shadow from thin washes of paint. By echoing the dark-brown tones of the foreground, Tanning leads the eye along the corridor, again heightening the composition's sense of depth.

Multiple doors are a motif often associated with dreams. Their presence denotes a literal manifestation of Tanning's fascination with dreams and the inner self. Long, door-lined corridors appear in many of her early works, including her well-known painting *A Little Night Music* (1943).

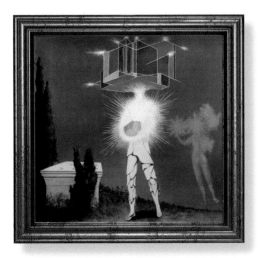

Sun, Moon, and Stars

1942, Private Collection

A PRECOCIOUS AND CREATIVE CHILD, Swiss artist Meret Oppenheim spent her youth in southern Germany. She began painting scenes from her dreams at just fourteen years of age. *Sun, Moon, and Stars* reveals that fifteen years later Oppenheim's dreams still formed that basis of her unique imaginings.

Oppenheim moved to Paris in 1932, determined to become an artist. She began her long association with the Surrealists the following year. Appreciative of her profound and often witty creations, the group embraced Oppenheim, but quickly cast her as the perfect embodiment of the Surrealist woman-child, the *femme-enfant,* whose charms they believed opened doors to unexplored realms of the unconscious. Oppenheim became the muse of several members of the group—Max Ernst, with whom she enjoyed a

1929	1932	1933
Her first "Surrealist" work; a pictorial equation, *X = rabbit,* which she later presents to André Breton.	Moves to Paris, studies briefly at the Académie de la Grande Chaumière.	Meets Swiss sculptor Alberto Giacommetti, in Café du Dome, Paris. He introduces her to the Surrealist Group.

passionate affair during 1934, and Man Ray, who celebrated her form in many photographs during his time in Paris.

Despite having undertaken only rudimentary art training, Oppenheim exhibited at the Surrealist Salon des Surindépendants in 1933 and enjoyed a close involvement with the group until 1937. In 1936 she executed her most notorious work, *Object*: a teacup, saucer, and spoon lined and covered in fur. The "fur teacup" was given the nickname *Lunch in Fur* or *Déjeuner en Fourrure* by André Breton. On her return to Basel, in 1937 Oppenheim undertook two years of intensive, formal training. As such, *Sun, Moon, and Stars*—painted just three years later—represents part of Oppenheim's formative *oeuvre*.

For Oppenheim the beginning of World War II coincided with a period of creative dirge. She described it as her "period of artistic and human crisis," claiming to have felt its effects until 1954. Turning to Carl Jung to explain her predicament, in 1945 she wrote in her diary: "*My king has cast me out: that was the animus, which Jung calls the masculine part of the female soul, just as the anima is the feminine part of the male soul. I had discovered that "the muse" of the male poet and artist is also an image of the anima, from which it follows that "genius" must be the image of the animus that watches over women artists and poets. And it was exactly that which had abandoned me.*"

Sun, Moon, and Stars is one of the few works surviving from this period; Oppenheim's infrequent bursts of inspiration were followed by phases of ritualistic destruction. Painted within the context of war, the zodiacal symbolism becomes a creationist narrative. The tomb, a visual representation of death, completes the cycle.

20 in (51cm)

19 in (48 cm)

Fact

The daughter of a psychologist, Oppenheim was familiar with the works of Jung, in particular his 1912 publication, Psychology of the Unconscious. Throughout her career, Oppenheim was concerned with the unconscious, or true inner self, which, like Jung, she differentiated from one's public persona.

Oil on canvas

1935	1936	1937	1938
Suffers from depression. Referred to psychoanalyst Carl Jung for treatment.	Creates her best-known work, *Lunch in Fur*.	Returns to Basel where she resumes her studies.	Attends School of Commercial Arts in Basel.

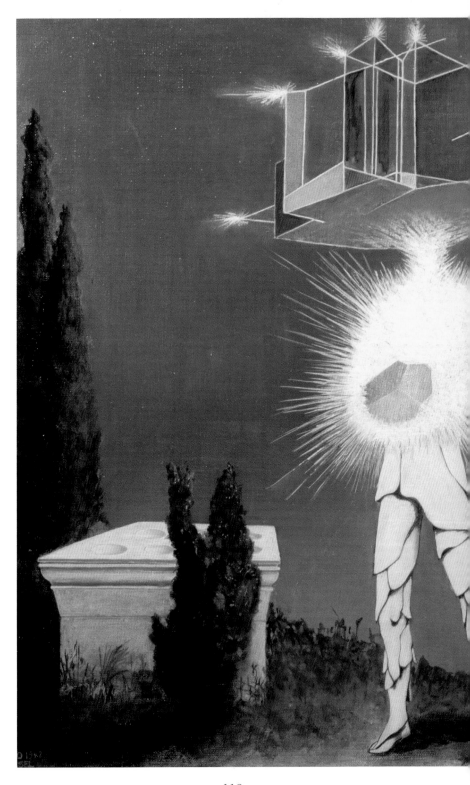

Sun, Moon, and Stars is set precariously on a cliff edge; Oppenheim depicts scrubby grass that falls away before an expansive twilight sky. Toward the center of the composition an extraordinary being is positioned, its head and torso obscured by radiating yellow rays; the figure represents the sun to which the title refers. Above the figure's head are eight bright stars; these shining points are joined, creating a regular cuboid matrix. This angular form offers futuristic or scientific connotations, at odds with the mysticism suggested by the rest of the composition. Floating beyond the "sun" is an ethereal female figure; a personification of the moon. This second human form is viewed from behind, as if presenting a mirror image of the illuminated "sun," highlighting their intrinsic connection.

Alternative interpretations of *Sun, Moon, and Stars* have described the rock formation at the center of the sun's rays as the "moon."

Although better known for her extraordinary, fetishistic assemblages than her paintings, Oppenheim created several works on canvas from 1937 onward. Although her style remained experimental, ranging from considered formalism to looser expressionism, areas of rich, Prussian blue dominated much of her *oeuvre*.

Lead yellow

Emerald green

Prussian blue

Ultramarine

Chromium green

Yellow ocher

Venetian red

By painting the sky over a muted ocher base, Oppenheim has added depth and richness to the blue paint and achieved a richer tone.

A twilight sky is presented in a rich, dusky blue-gray, which fades toward the outer edges. The thin paint reveals, in areas, an ocher base coat, which adds depth and dimension to the expansive space. The landscape within which the figure is positioned is painted in naturalistic tones of brown, emerald, and gray. Blue-toned highlights visible in the dense foliage of the cypress trees provide continuity between earth and sky. The planes of the cuboid form linking the stars are painted in strong tones of burgundy, olive green, gray, and blue. These planes are defined by perpendicular lines of pale yellow; the same tone is used to suggest the fracturing rays of the stars and sun. Only three objects are paler, painted in cool white tones: the vaulted tomb, the visible midriff and legs of the anonymous central figure, and the ghostly figure floating to the right of the picture plane.

Oppenheim chose the complementary colors of a purple-blue sky and the pale yellow rays of the sun to create visual harmony.

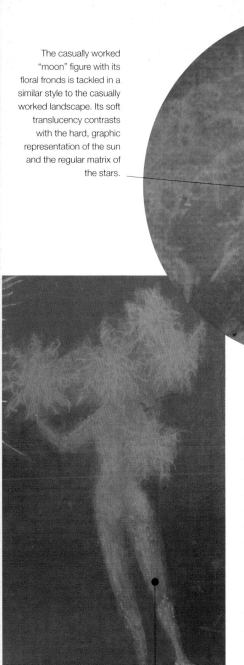

The casually worked "moon" figure with its floral fronds is tackled in a similar style to the casually worked landscape. Its soft translucency contrasts with the hard, graphic representation of the sun and the regular matrix of the stars.

Oppenheim appears to have drawn the ethereal "moon" figure onto the dry background using oil pastel, and gently blended it to produce a translucent finish.

Although painted in oils, at first glance Oppenheim's delicate brushwork and thinly layered paint is reminiscent of the dynamic watercolors of the eighteenth-century visionary William Blake. This comparison is heightened by the mystical figures that populate Oppenheim's composition, suggesting a modern re-imagining of Blake's mythological or biblical subjects. Oppenheim first prepared her canvas with a muted ocher ground, which she worked on in thin layers of diluted oil paint, using a soft brush. A close look at *Sun, Moon, and Stars* reveals that the rich, blue sky was completed first, followed by the scrubby grass and shadowy conifers that dominate the foreground. The illuminated, central figure was painted last, in considerably thicker paint; the yellow light that radiates from its torso yields heavy impasto, at odds with the qualities usually associated with light.

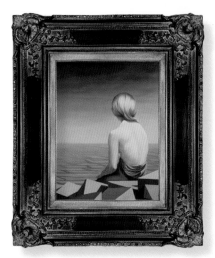

KAY SAGE, 1898–1963

The Passage
1956, Private Collection

KAY SAGE'S POSITION WITHIN THE HISTORY OF SURREALISM is a privileged one. Moving to Paris in 1937, having lived, and studied painting, in Rome, she became the only woman to be associated with André Breton's Surrealist Group as a practicing artist—as opposed to a muse, wife, or lover. Through her association with the Parisian Surrealists, Sage met Yves Tanguy. The couple began a long and tumultuous relationship, marrying soon after leaving war-torn Europe for the United States in 1940.

By 1939, Surrealism in Europe had lost momentum, many of its key figures having left due to the threat of war. However, in the United States, to where many of them fled, Surrealism gained impetus, attracting new members and enjoying enthusiastic support into the 1960s.

1937	1939	1940
Moves to Paris, joins the Parisian Surrealist movement.	Meets Yves Tanguy. Both participate at Surrealist exhibition, Salon des Indépendants.	Returns to United States with Tanguy.

As a young painter Sage was influenced by the open spaces, architectural forms, and classical references of Giorgio de Chirico. Throughout her career, Sage's compositions featured mysterious architectural elements that appear strangely insubstantial, like flimsy stage sets. In later works, including *The Passage*, the influence of Tanguy, and indeed Salvador Dalí, is evident in the vast, desert landscapes that Sage constructed. Like Tanguy, she renders light with a mysterious, luminous quality that fades in the distance into hazy, gray tones.

The Passage is a melancholy self-portrait, painted the year after Tanguy's death in 1955. It does not feature the architectural structures so often central to Sage's compositions; these are replaced by the unnaturally regular forms of the landscape, namely, cuboid boulders in front of a uniformly divided matrix of desert. One of the few works in which she depicted the human form, significantly seen from behind, *The Passage* is one of the last major paintings Sage produced before she was thwarted by depression, alcoholism, and failing eyesight. The title, which refers to Tanguy's death, seems also to anticipate her desperate suicide in 1963.

As a Surrealist, Sage sought to depict the conditions of the human mind. Although aware of psychoanalytical theory, her compositions are based on personal experiences and emotions. The desert scenes that seem to parallel those of Dalí and her husband Tanguy do not represent untamed spaces in which anything is possible, but refer to feelings of isolation that dominated her own life—her isolation and struggle as a woman artist in the early twentieth century, as well as her often masochistic relationship with Tanguy.

28 in (71.1 cm)

36 in (91.4 cm)

Fact

The final years of Sage and Tanguy's marriage were strained. Acquaintances noted that Sage was subjected to frequent verbal attacks from her husband, but rarely retaliated.

Oil on canvas

1941	1954	1955	1956
Sets up home in Woodbury, Connecticut where Sage paints prolifically.	Sage and Tanguy hold joint exhibition.	Tanguy dies of cerebral hemorrhage. Sage curates his retrospective exhibition.	Completes *The Passage*, a personal response to her husband's death.

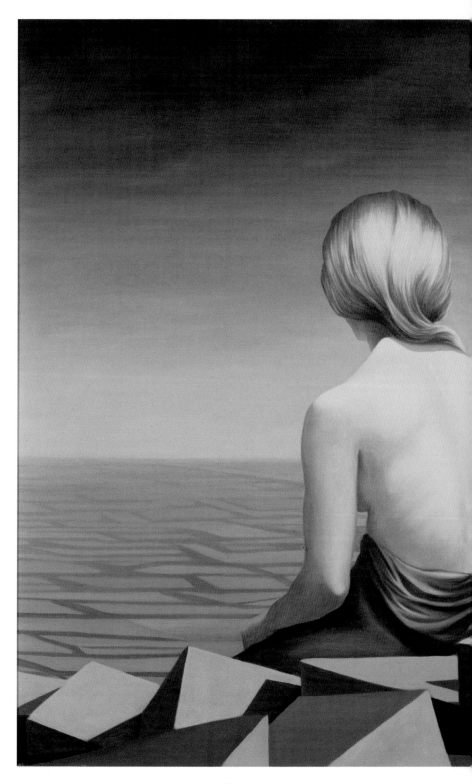

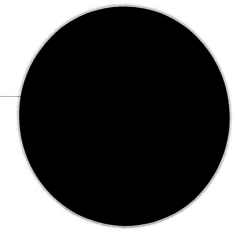

The combination of barren, drought-cracked land and the threat of rain creates a sense of awaiting the inevitable, an allusion to the certainty of death.

The figure is turned away from the viewer, a visual metaphor for anticipating the future. The obscured face also suggests an uncertain sense of identity.

A naked figure is seated with her back to the viewer, a garment draped loosely around her waist. She looks out over an imaginary desert landscape. The ground is scored by regular lines, a geometric vision of cracks at the bottom of a drought-stricken lake. The cliff upon which the figure is seated is comprised of sandy rocks similarly regular in shape, their edges sharp, as if recently cut from a quarry. The uniformity of the landscape creates a sense of unease that is intensified by the contrast of a tumultuous sky, heavy with dark rain clouds that hang above the scene.

Sage often painted shadowy night scenes dominated by planes of dusky blue and gray, with areas of rich shadow. By comparison *The Passage* features a warmer palette of cream and ocher tones.

The picture plane is bordered at the top and bottom by the same dark tones; both the distant clouds and the shadows of the boulders in the foreground utilize the same gloomy tone reminiscent of Indian ink, based on raw umber and Prussian blue. The pale layers of clouds below the storm are echoed similarly in the boulders' lit edges, in which subtle grays are warmed with yellow ocher. The warmest tones are found in the middle of the composition, in the figure's luminous peach skin, the shadows of which resonate with the barren land in the distance. Like the Old Masters, Sage illuminates the composition's focal point, in this case the figure, with radiant highlights.

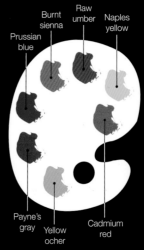

The thinnest paint is situated near to the horizon; close inspection reveals the cream canvas ground visible beneath.

By using colors from the same tonal range, Sage achieves visual continuity, relying on pattern and texture to lead the eye.

Prussian blue

Burnt sienna

Raw umber

Naples yellow

Payne's gray

Yellow ocher

Cadmium red

During the 1920s Sage studied in Rome, where she learnt Classical painting techniques, including fresco. The fruits of this training are evident here, in the way that she layers paint, minimizing areas of impasto and creating subtle tonal variations.

Sage was an accomplished painter and fine draughtswoman. *The Passage* is painted with characteristic delicate brushstrokes, almost invisible to the eye. The brushstrokes curve around the form, creating a three-dimensional sense of light and shadow. Sage painted methodically, preparing the canvas with a soft, gray ground, which forms the basis of the melancholy sky. The sky is rendered in diluted paint of graduating gray tones which are applied in even, horizontal brushstrokes. The tones intensify toward the top of the picture plane and run together, creating heavy clouds. A wash of diluted gray paint, applied with a soft brush, glazes the ground from the horizon to the middle ground, suggesting creeping mist.

In contrast to the loosely formed background, Sage painted the figure's hair with fine, delicate brushstrokes that trace the path of each strand.

Sage painted shadows in thin washes of paint through which previous colors remain visible. The technique adds a luminous quality to the figure's skin.

Index